MYFANWY MACLEOD

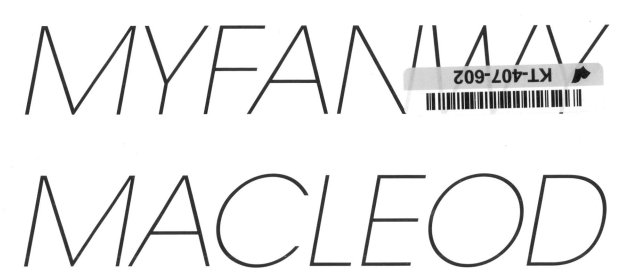

Books are to be returned

AND BACK

Vancouver
Artgallery

MUSEUM | LONDON

MYFANWY MACLEOD, OR THERE AGAIN

Curated by Grant Arnold and Cassandra Getty

Texts by Grant Arnold, Josée Drouin-Brisbois, Cassandra Getty,
Joseph Monteyne, The Music Appreciation Society

**black dog
publishing**
london uk

CONTENTS

FOREWORD

Kathleen S. Bartels and Brian Meehan

DIRECTOR
Vancouver Art Gallery

DIRECTOR
Museum London

Over the past twenty years Myfanwy MacLeod has become widely known for her irreverent work that brings together an eclectic set of references, from conceptual art and Minimalism to motifs salvaged from popular literature, music and cinema. She has, for example, deployed overt references to Stanley Kubrick's *The Shining*, appropriated the lyrics of Jethro Tull's "Bungle in the Jungle" and incorporated sculptural motifs that recall the classic cartoons of Chuck Jones or the 1968 British musical film *Chitty Chitty Bang Bang*. Layered with humour, fantasy and allusions to forbidden desire, her work—which includes sculpture, drawing, painting and photography—is simultaneously amusing and disconcerting. It evokes surprising points of intersection between iconic moments in mass entertainment and the history of modern art, while situating the sometimes arcane world inhabited by artists, critics and curators as a mirror for the culture at large.

Museum London and the Vancouver Art Gallery are honoured to present *Myfanwy MacLeod, or There and Back Again*, an exhibition comprised of a new body of sculptural work—in which the music of Led Zeppelin and the writing of J.R.R. Tolkien are key references—in combination with a diverse range of origami, sculpture, painting and photography MacLeod has produced over the past decade. As reflected in its title, the exhibition has been structured to suggest a cyclical journey in which one's departure from the familiar into parts unknown becomes a process of self-discovery that concludes with the return home. Given this configuration, the collaboration between our two institutions is particularly appropriate, as MacLeod was born and raised in London and has been based in Vancouver for much of the past two decades.

This exhibition and publication have been made possible through the support and contributions of a number of individuals and organizations. We appreciate the generosity of the lenders, both private and institutional, who have kindly loaned artwork from their collections and the assistance provided by the Catriona Jeffries Gallery in bringing together the work for the exhibition. We extend our thanks to Black Dog Publishing, especially Duncan McCorquodale, Albino Tavares and Nick Warner, for their work in realizing this excellent publication and to contributing writers Josée Drouin-Brisebois, Joseph Monteyne and The Music Appreciation Society for their illuminating discussions of MacLeod's work.

Our sincere thanks go to Cassandra Getty, Curator of Art at Museum London and Grant Arnold, Audain Curator of British Columbia Art at the Vancouver Art Gallery, for their stellar work in organizing the exhibition and for their thoughtful contributions to this publication. We also extend our deep appreciation for the support provided by the Boards of Trustees of our respective institutions. The Vancouver Art Gallery is grateful for the financial support provided for the Vancouver presentation of the exhibition by Visionary Partner David Aisenstat, by Douglas E. Bolton and by Jane Irwin and Ross Hill. We also acknowledge generous support for this publication provided by RBC Foundation. Lastly, and most importantly, we extend our profound gratitude to Myfanwy MacLeod for her humorous, engaging, compelling and thought-provoking work.

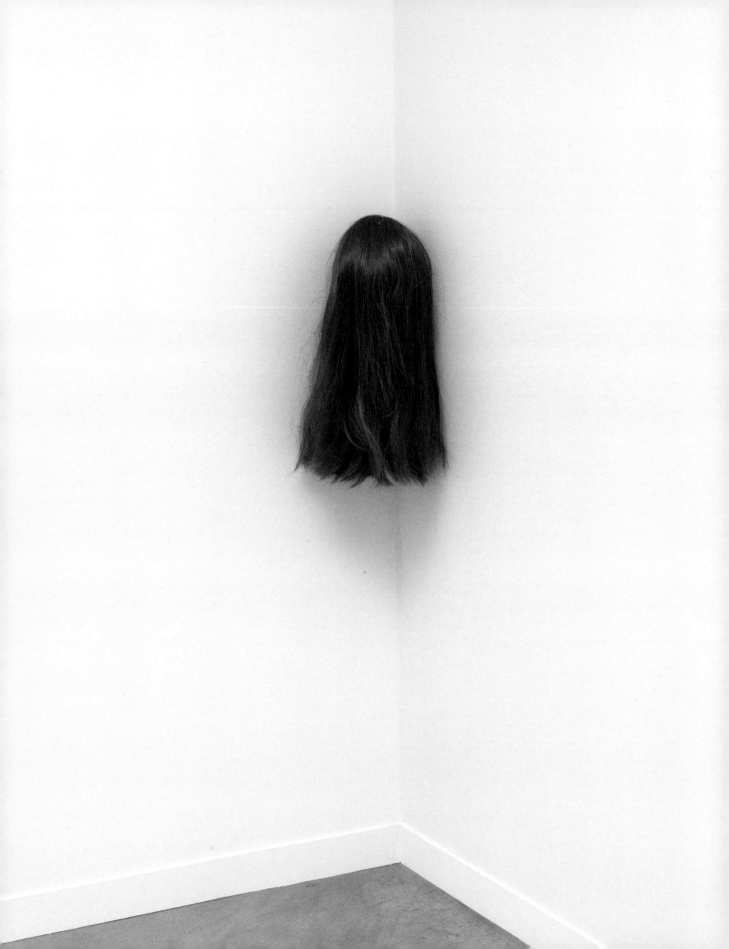

THEN AS IT WAS, THEN AGAIN IT SHALL BE: AN INTRODUCTION

Cassandra Getty

Myfanwy MacLeod, or There and Back Again explores the complex and irreverent artwork MacLeod has made over the past fifteen years. MacLeod's practice encompasses a variety of themes and media. Everyday items such as cartoons, movie and rock band posters, soft porn magazines, snapshots, and folk and children's crafts become tools to challenge assumptions about art, class privilege and other social conventions. Born and raised in London, Ontario and for years based in Vancouver, she has established an impressive and consistent artistic presence that speaks to and bears the influence of both environments.

The content and methods explored in her work probe social and philosophical questions. Often described as a second-generation Vancouver conceptualist, her work combines popular imagery with conceptual rigour. The intimacy of familiar, even "homey" elements welcomes the viewer and encourages her or him to construe their own personal meanings from the work; its ubiquity also permits the layering of other, often ambiguous or paradoxical meanings, which include more unsettling possibilities associated with life on the social margins.

This co-publication between Museum London and the Vancouver Art Gallery documents two versions of the exhibition, which share a core group of paintings, prints and sculptures, including the new large-scale sculptural works, *Stack* (2013) and *Ramble On* (2013). Three additional works—titled *Albert Walker*, *Dragon* and *Presence*—were produced for the presentation in Vancouver. Through these and a range of earlier works, her exceptional practice and distinctive outlook can be examined.

MacLeod's use of familiar materials, formats and cultural references is central to her practice. Indeed, she has stated that "pop culture is the language I know and I'm using that language to speak to more profound things."[1] Wry exhibition titles such as *Gold* evoke the cheesy 1980s music program *Solid Gold* and Ronco album sets.[2] The phrase "there and back again" recalls both J.R.R. Tolkien's classic novel *The Hobbit* and 1970s cultural references including Led Zeppelin and the animation of Ralph Bakshi. It is thus not surprising to find in the installation a Farrah Fawcett-haired mannequin "groupie," clad in a "Stairway to Heaven" t-shirt, alongside feral, heavy metal–style vinyl lettering that spells out such statements of teen angst as "The Emptiness" and "Lost Inside." In the same line of inquiry is *Stack*, which replicates a "Marshall stack" of amps—popularized by such bands as The Who, that is still in use today. The work's grid form also playfully mimics the type of display configuration favoured by Minimalist artists.

The exhibition title, ... or There and Back Again, refers to the concept of the *Bildungsroman*, or narrative trope, in which the protagonist embarks on an odyssey that leads not only through the plot but also to the character's self-realization, as in *The Hobbit* and *Lord of the Rings*. The title also references the longitudinal scope of the survey-show format. An important, more specific link to this notion of struggle comes in *Don't Stop Dreaming*, a 2004 installation reformulated for London and Vancouver that alludes to a similar sort of personal journey, the difficult yet fulfilling struggle of the artist.

In *Don't Stop Dreaming*, MacLeod placed two geodesic dome–shaped speakers, bought at a pawn shop, on a

P. 8
Torso of a Young Girl, 2006
nylon wig
51.5 x 24 x 2.5 cm
Collection of the Vancouver Art Gallery,
gift of the artist

Michael, Carrie and Rosemary, 2010
(detail)
three cut film posters
120 x 105 cm each
Courtesy Catriona Jeffries Gallery

carpet in front of a large photomural of a dark forest.[3]
The surrounding walls, also black, focus attention on the
equipment, which resounds with two enmeshed soundtracks.
One component excerpts audio from the movie *The Beach*
(2000), in which the protagonist, played by Leonardo
DiCaprio, describes in almost hallucinatory terms his quest
for "paradise." Imbedded in the techno music of an aerobics
class, a second voice—that of a spin class instructor—urges
listeners to "Keep it up! Push! Push! Feel the momentum

you've created! Hold on to that determination! Make your
time worthwhile while you're here."[4] While the experience
extrapolates to contemporary life generally, the inspiration
arguably applies also to the special level of commitment
demanded of artists and other creators, whose livelihood
comes so utterly from their own ingenuity and imagination.

... *or, There and Back Again* also bears traces of MacLeod's
early life in London. The Zeppelin-riffing *Ramble On* (2013),
comprises a 1977 Camaro Rally Sport long owned by a
member of the artist's family.[5] Now installed sideways on a
car rotisserie, it exists simultaneously as a memory of youth
spent in southwestern Ontario and a nod to modernist
sculpture. It is foremost a symbol of fun and freedom (the
artist recalls its aptitude for spinning "donuts" in the 1980s)
and injects some conviviality into the canon of modernist
art.[6] Drawn using orange pencil crayon, MacLeod's *Small
Landscape* drawings (2005), are based on family photographs,
but provide sparse detail within their blank borders. This
haziness may be analogous to the fading of memory and
perhaps the physical body over time; the smaller, inchoate
scope of youthful knowledge; or the idea of a home as less
than stable or memorable. Indeed, many of MacLeod's works
refer to a past wrongly identified as an idyllic golden era, and
feed on assumptions of the landscape as bucolic and romantic.

The faux-ramshackle outhouse *Tiny Kingdom* (2001),
an obsolete edifice now distanced from its original purpose,
perhaps scorns such superficial views of the past through
irony and exaggeration. The cord of wood re-imagined
in concrete that is *Wood for the People* (2002), is similarly
useless in pioneer terms. Arranged about the entrance to the
Morris and Helen Belkin Art Gallery at the University of

Wood for the People, 2002
230 cast concrete logs
366 x 48 x 183 cm overall
Collection of the Morris and Helen
Belkin Art Gallery, Vancouver

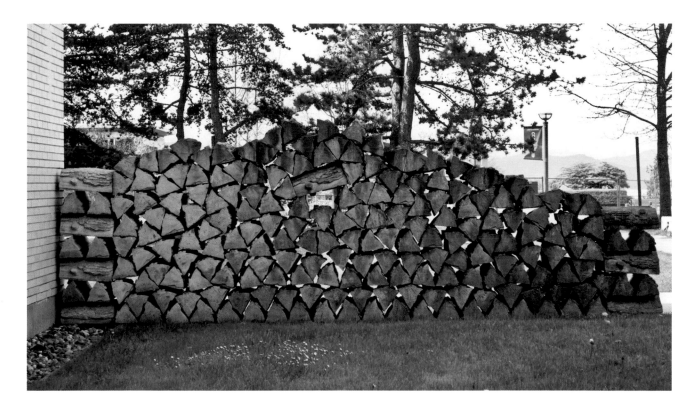

British Columbia in Vancouver, it perhaps better serves to stir intellectual fires about Minimalist and site-specific art. It introduces familiar and narrative content into a category of sculpture often seen as formal and inert, comprising a barricade outside—or shut out from—what is unfortunately often considered a bastion of elitism. In such tongue-in-cheek peeks back, could not the outrageous and sarcastic "backwardness" of MacLeod's gestures be viewed as a poke in the eye to nostalgia for a picturesque life and High Modernism?

An emphasis on North American culture of the nineteenth and early twentieth centuries can be seen in a range of subsequent projects. *Everything seems empty without you* (2009), labelled MacLeod's "monument to alcoholism," embraces the form of a backwoods still and is also a satirical riff on Donald Judd's Minimalist sculpture.[7] The sprightly introductory text featured in the *Complete Practical Distiller* (2009), mimics the florid, prolix flair of antediluvian "book learnin'." Other projects work the same

The Ladies Succumb, 2011
decoupage on Hendrick's Gin bottle
20 x 9 x 9 cm
Courtesy Catriona Jeffries Gallery

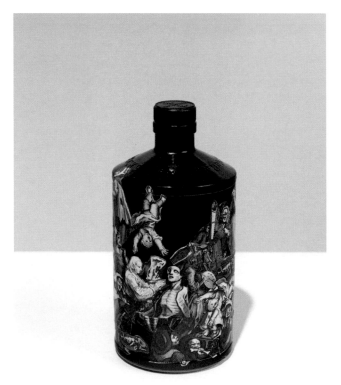

piece of road, but more clearly implicate viewers in a type of social accounting. There is the whittled simplicity of *Our Mutual Friend* (2002), which features a toe poking drolly from a battered boot; the decoupage-like phantasmagoria of *Drunkard's Walk, or How Randomness Rules Our Lives* (2008), in which MacLeod compiled antique caricatures of rustic dipsomaniacs; and the resin form of a stumbling bum, *The Littlest Hobo* (2009), cast in a mantelpiece-friendly stature. At first glance all are innocently and uproariously ridiculous. Though their absurd charm remains, it is dampened upon further consideration of their shared content—alcoholism and poverty, and its resultant isolation and debility.

Even titles such as *The Ladies Succumb* (2011), a bottle ornamented against the dangers of drink, and *Miscreants and Reprobates*, the name of an exhibition at Vancouver's Charles H. Scott Gallery emphasize this dual principle.[8] In this insightful project, MacLeod's art was displayed alongside the exhortative imagery of eighteenth-century artist William Hogarth, best known for his moralizing series of illustrations on vice such as *The Rake's Progress, Industry and Idleness, Beer Street* and *Gin Lane*.[9] The proximity of the two approaches—one cheeky and the other more shrill—emphasizes not only the continuing problem of alcoholism, but of social stigma, stereotyping and melodrama. MacLeod's use of wit does not mock the subjects she represents. When one "doesn't know whether to laugh or cry," the gesture of looking on the sunny (or at least ironic) side of things asserts a tenacious attitude of cleverness and integrity.

Much of MacLeod's practice investigates life on the margins, including such "backwoods" activities as making moonshine, and the aesthetics with which they are associated. In several of these recent projects, MacLeod again references art historical benchmarks. Her *Hex* paintings of 2009, for example, borrow patterns and symbols found in painted signs decorating the barns of Pennsylvania Dutch farmers. Such signs originally served an apotropaic function that dwindled into ornament. MacLeod thus inserts into the

Ain't nothing ever happened, 2009
enamel on wood
183 x 244 cm
Private Collection

"white cube" context these conventions as her own take on hard-edged abstraction, splicing the forms and meanings of "craft" with what curator Josée Drouin-Brisebois jokingly refers to as "bona fide" paintings.[10]

A related painting on panel, *Ain't nothing ever happened* (2009), conflates the longstanding practice of quilting with the history of nonrepresentational painting, indicating shared ingenuity across what's seen as "high" and "low" art. MacLeod's painting riffs on the innovative quilt designs associated with the black women quilters of Gee's Bend, Alabama, whose work first garnered acclaim in the 1990s. To further complicate the question, *Ain't nothing ever happened* (and the *Hex* paintings) were fabricated for MacLeod by a professional sign painter. Together, these works skewer the concept of artistic genius and the sense of intellectual superiority that has traditionally elevated predominantly male artists above those who work in more popular fields of expression, while consigning the work of rural and often female creators to the sphere of the quaint and frivolous. In the case of *Ain't nothing ever happened*, race should also not be overlooked. MacLeod has mentioned that the work's title is based on a retort one of the quilters made when asked about the effects of the popularity of the quilts from Gee's Bend. The phrase symbolizes a tacit inclination in North American culture to ironically absorb influence from minority communities, yet refuse to assign equal status to the original achievements. MacLeod's work is thus about good ol' boys and the ol' boys' club.

MacLeod's dichotomy of humour and terror has been described as an exploration of the contemporary society's collective unconscious.[11] Writer Deborah

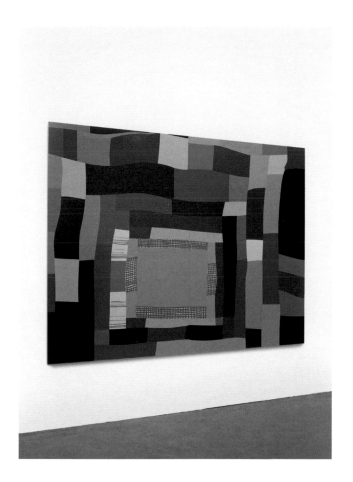

Campbell associated the artist's interest in horror with Jean Baudrillard's claim that today's sanitized and pampered populace is yet "as scared to see the lights go out as was the hunter in his primitive night."[12] I would suggest it also draws upon a culturally based fascination with the unseen. In an

The Birds, 2010 (detail)
public artwork, 450 cm in height,
commissioned through the City of
Vancouver's Olympic and Paralympic
Public Art Program.

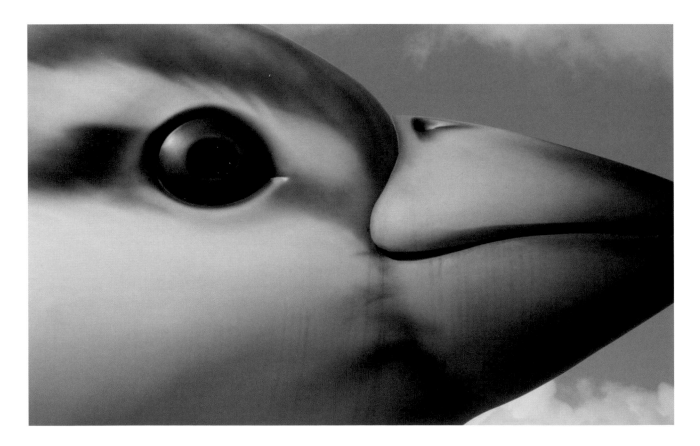

interview the artist noted different cultural conceptions of ghosts encountered in her European travels:

> I found that in France they don't have ghosts so much as time rifts—slipping back in time…. But in England, ghosts and haunted houses are more common… actually there are a lot of ghosts in Canada but I think that's mostly a reflection of the immigrant culture and the fact that so many people from the British Isles brought their ghosts with them when they emigrated.[13]

This interest was intensified during her stay in Scotland in 2005 for the Glenfiddich Artists in Residence program.

The residency took place in the northern community of Dufftown, near Aberdeen, in an area of recently vacated buildings that also carries traces of earlier periods of depopulation, whether to urban centres for work in the nineteenth century or further abroad as a result of the Clearances. In an interview MacLeod noted Dufftown "was so desolate that it probably didn't help that I was reading Stephen King."[14]

From this experience she produced a body of photographs of decaying homes, and two installation works. *Bound* (2006), consists of a white carpet marred by a grotesque tat of hair, suggesting forensic evidence or a macabre class of haunting presence. In *Torso of a Young Girl* (2006), a child's wig faces into a corner in a manner that recalls the ending sequence of *The Blair Witch Project*.

All these works continue with a pop culture subtext. This affinity is even stronger in *Michael, Carrie, and Rosemary* (2010), in which Michael Jackson's image for the *Thriller* album cover and posters for the horror movies *Carrie* and *Rosemary's Baby* are cut into child-like snowflake patterns that attract and repel the viewer's gaze. Discussing a similarly cut poster of *The Exorcist*, critic Peter Culley likened the excerpted appearance to the subliminal flashes of the demon's face in the 1973 movie.[15] A similar feeling of suspense prevails in MacLeod's first major public commission, *The Birds* (2010), which consists of sixteen-foot sculptures of a male and female sparrow that stand at Southeast False Creek Olympic Plaza in Vancouver. By exploding the birds' size, the artist heightened their impact. Their fun-park gigantism is both amusing and ominous, relating to the Daphne du Maurier story-turned-Alfred Hitchcock film *The Birds*, and commenting on the problem of invasive species.

More recently, MacLeod has used centrefolds from men's magazines to produce complex origami shapes. The process reveals only snippets of a woman's body, that of British Columbia-born *Playboy* model, film starlet and domestic murder victim Dorothy Stratten. The mix of recognizable figural content with the detached, more abstract forms that emerge suggests gentle humour, but also taboo. The literally incomplete "picture" may symbolize the extinguished human potential and the inability to know an individual so commodified by the Hollywood system. MacLeod offers fraught elements of celebrity "branding," Stratten's objectification by the Hefner empire and her exploitation by her paramour director Peter Bogdanovich and her murderous ex-husband Paul Snider to assert that "[t]he story [of Dorothy Stratten] is something that's real, and not real at the same time."[16]

Discussing her practice generally, MacLeod has noted that "I do things intuitively. I start first and the conceptual stuff happens along the way."[17] Her incisive work is a catalyst for rumination on wide cultural topics, her references myriad and accessible. The atmosphere of some of her pieces recalls the fourteenth-century allegory of the *Decameron*, in which stories are told to entertain and instruct while adversity exists outside the gates. With their joyful pratfalls, anger and tragedy, MacLeod's imaginative efforts—like those tales—reflect and engage with the larger world.

Endnotes

1 Deborah Campbell, "Pop Pastoral," *Vancouver Review*, 2006, accessed online
 September 1, 2011 at www.vancouverreview.com/past_articles/poppastoral.
 htm+&cd=1&hl=en&ct=clnk&gl=ca&client=firefox-a.

2 The exhibition *Gold* was presented at the Catriona Jeffries Gallery in 2009.

3 In a previous incarnation of this work, the backdrop featured cherry blossoms.
 See Robin Lawrence, "'Dreaming' Is a Sound Exercise in Frustration," straight.com,
 September 23, 2004, accessed online September 20, 2012, at http://www.straight.
 com/article/dreaming-is-a-sound-exercise-in-frustration.

4 Lawrence, "'Dreaming.'"

5 MacLeod noted that "Led Zeppelin is something I totally associate with London,
 Ontario, where I grew up." "Agenda," *Canadian Art*, Spring 2013, p. 27.

6 Likewise *The Jet-Set*, 2013, print is a new work based on a sticker taken from the
 sun visor of the Camaro. The sticker is an ad for Dutch coffeehouse and depicts
 the slogan "Keep it High." The work is a part of MacLeod's longtime interest in
 the paraphernalia associated with "stoners, potheads and cannabis subculture."
 Press release from Or Gallery, Vancouver, accessed online September 1, 2013 at
 http://bricksandmortar.orgallery.org/post/56460451041/myfanwy-macleod.

7 "Myfanwy MacLeod: Not Just the Good Old Boys," *Canadian Art*, November
 26, 2009, accessed online March 12, 2011 at http://www.canadianart.ca/see-
 it/2009/11/26/myfanwy-macleod/.

8 This exhibition was curated by Cate Rimmer in 2011. Other wry phrases are the titles
 of the sketches *Miss Moonshine*, *Duelling Banjos*, *O Death*, *Barndance Sweethearts*,
 Like Kin be Beautiful, *Little Sparrow* and *Lonesome Valley* (all 2001).

9 The approach has a long line of antecedents, most obviously Hieronymus Bosch's
 Ship of Fools, ca. 1490–1500, and *Garden of Earthly Delights*, 1500–1505, and Pieter
 Brueghel the Elder's Wedding Dance of 1566. MacLeod's approach also creates a
 figural knotwork of the earthy and grotesque.

10 Josée Drouin-Brisebois, "Myfanwy MacLeod: The High-Art Lowdown," *Canadian
 Art*, March 18, 2009, accessed online April 6, 2011 at http://www.canadianart.ca/
 reviews/2010/03/18/myfanwy-macleod-2/.

11 Campbell, "Pop Pastoral."

12 Ibid.

13 Ibid.

14 Ibid.

15 Peter Culley, "The Ghost Whisperer," *Fillip*, No. 3, 2006, p. 5.

16 Meredith Carr, "There's No Place Like Home: The Return of Dorothy Stratten,"
 Decoy Magazine, October 31, 2012, accessed online November 6, 2012 at http://
 decoymagazine.ca/theres-no-place-like-home-the-return-of-dorothy-stratten/.

17 Danielle Egan, "Big Birds," *Canadian Art*, Spring 2011, p. 71.

Our Mutual Friend, 2002
yellow cedar
33 x 66 x 38 cm
Private Collection

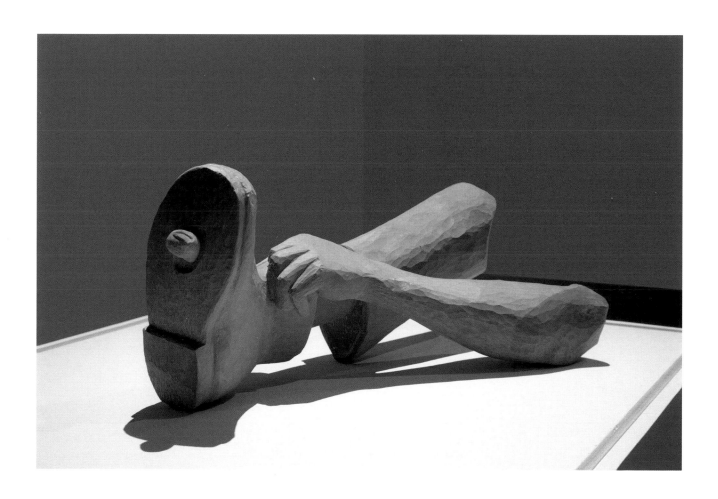

Мудрац

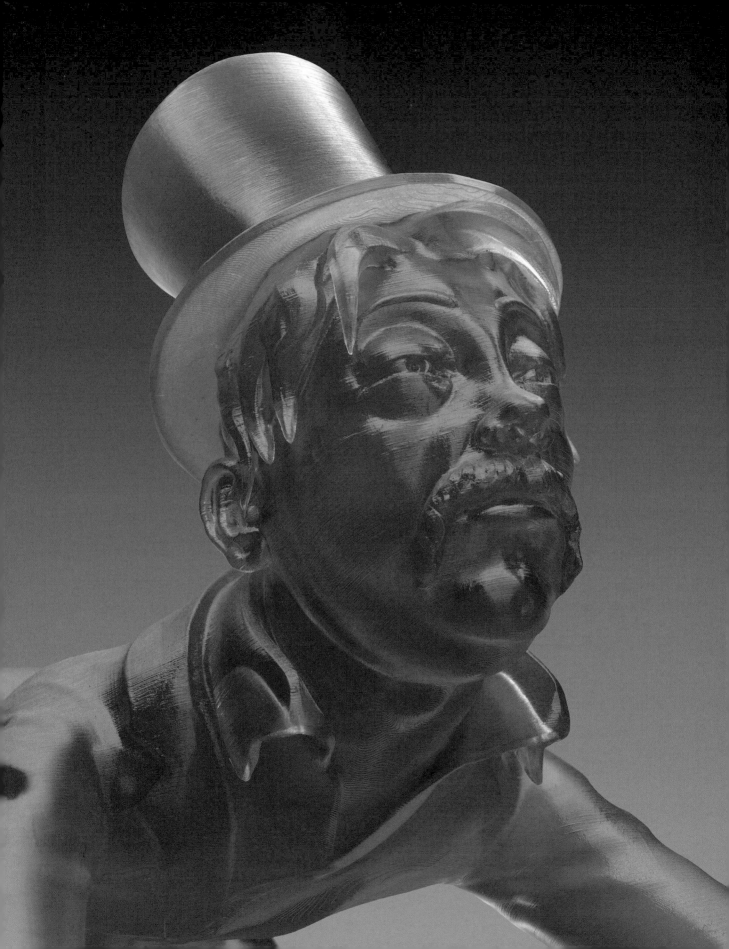

THEN AS IT WAS,
THEN AGAIN IT SHALL BE: AN INTRODUCTION

PP. 18–19
A Shady Place, 2002
cedar picnic table
64 x 184 x 20 cm
Collection of Museum London

OPPOSITE AND BELOW
The Littlest Hobo, 2009 (detail opposite)
3D printed acrylic resin
23 x 16.5 x 37 cm
Courtesy Catriona Jeffries Gallery

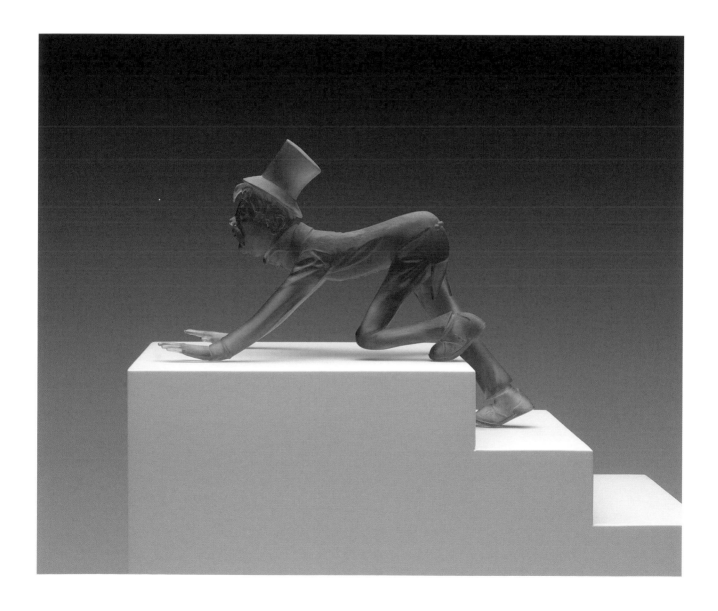

*The Drunkard's Walk, or How
Randomness Rules Our Lives*, 2008
inkjet print on paper
87 x 156 cm
Courtesy Catriona Jeffries Gallery

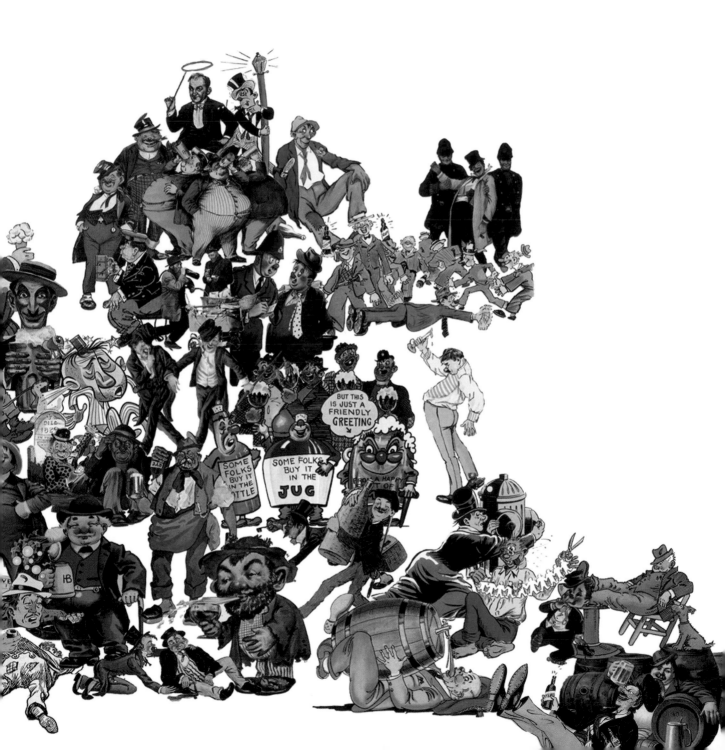

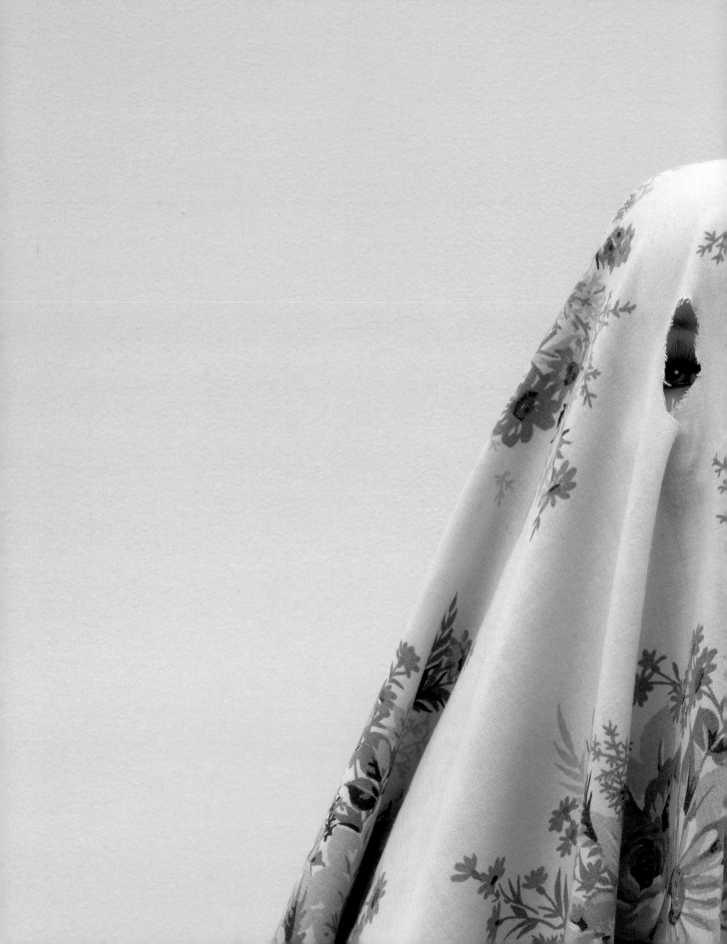

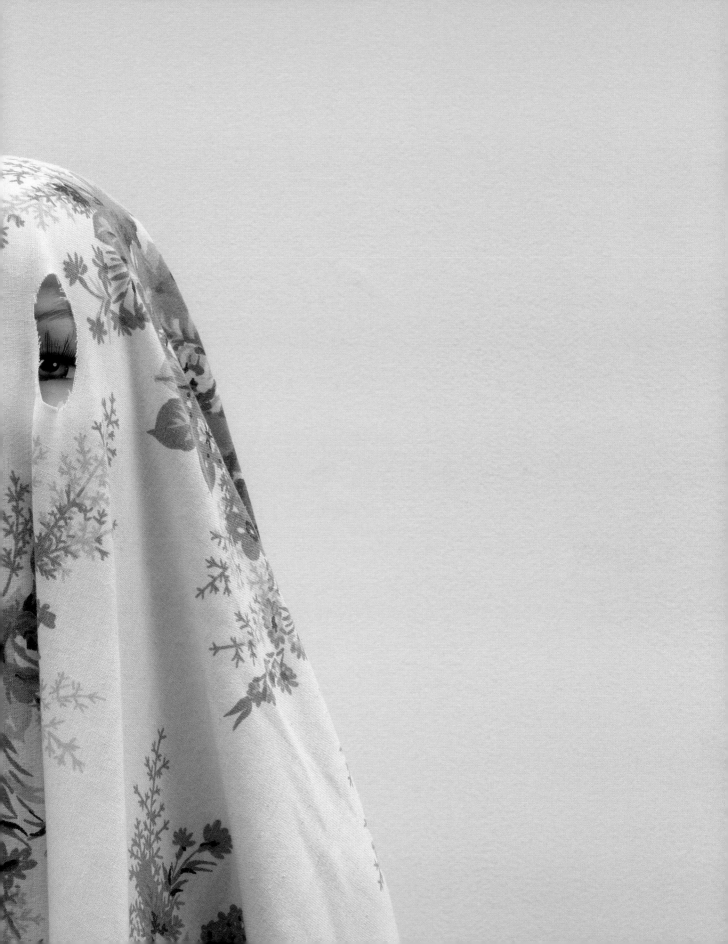

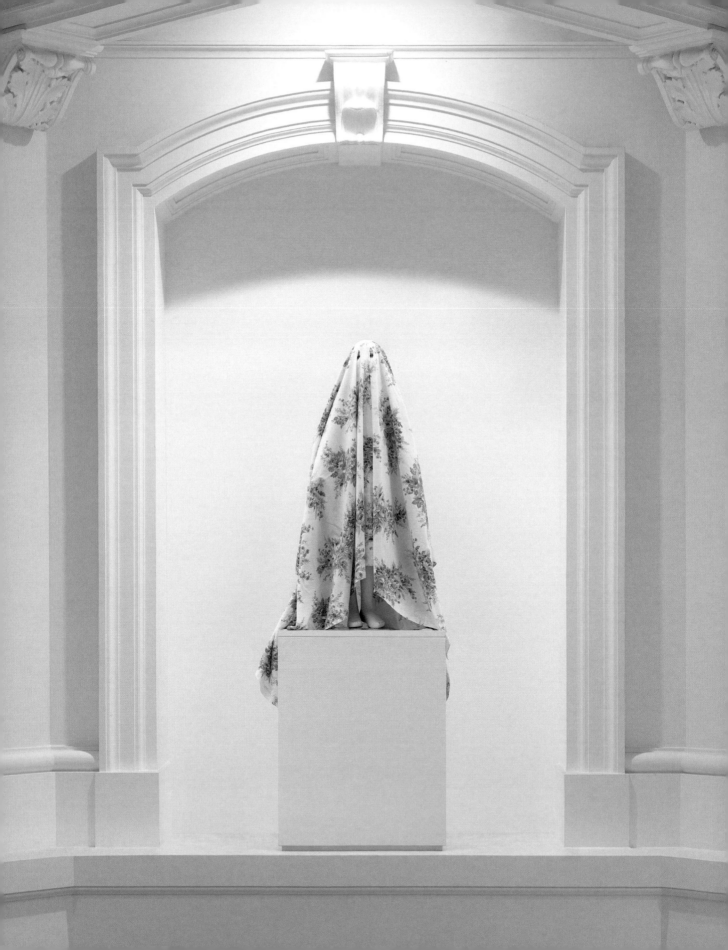

PP. 24–25
Ghost, 2006 (detail)
mannequin and second-hand bedsheet
122 x 61 x 61 cm
Courtesy Catriona Jeffries Gallery

OPPOSITE AND BELOW
Ghost, 2005–2011 (details of installation
version)
four mannequins, four second-hand
bedsheets
122 x 61 x 61 cm each
Courtesy Catriona Jeffries Gallery

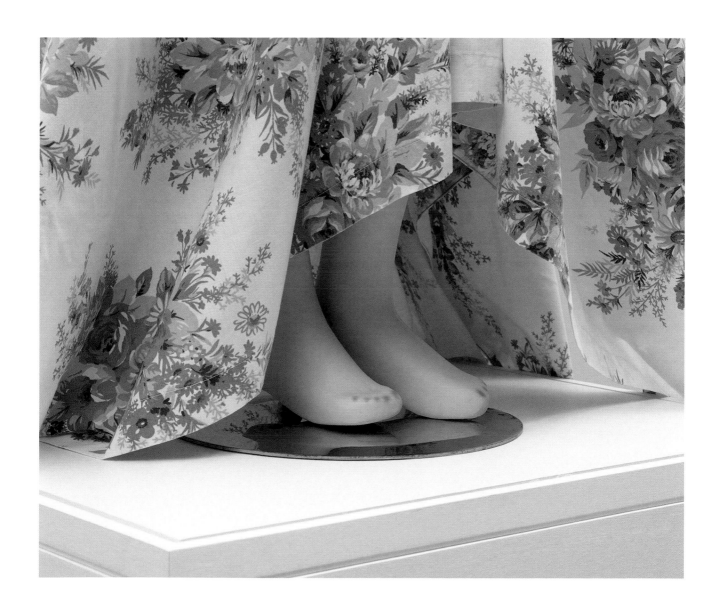

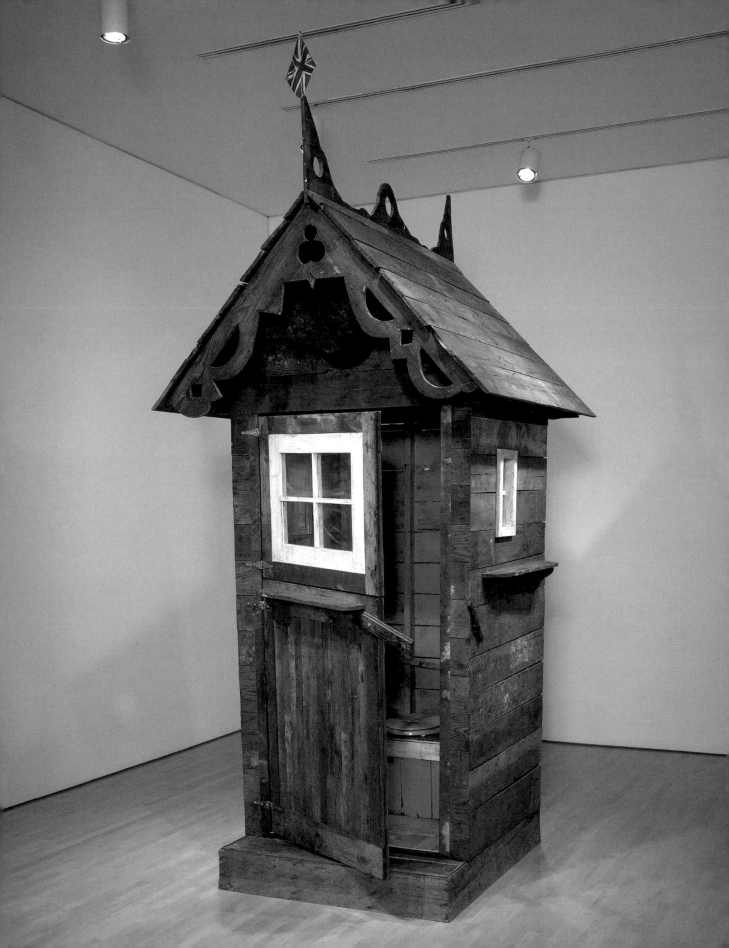

DEAR MYFANWY, EVERYTHING SEEMS EMPTY WITHOUT YOU

Josée Drouin-Brisebois

Nothingness is present everywhere. Without it, chaos would return.

To engage with Myfanwy MacLeod's work is to embark on a journey. As the title of this exhibition suggests, a journey can take you to faraway places and right back to where you started. The title is also a reference to *The Hobbit, or There and Back Again*, an epic tale of a perilous quest to reclaim a treasure stolen and guarded by a fierce dragon, hidden deep within a distant mountain. Written by J.R.R. Tolkien in 1937, the main protagonist of the story is Bilbo Baggins, a reclusive hobbit (an imaginary race similar to humans although of smaller size and with hairy feet) who is convinced by a wizard to embark on the dangerous mission in the company of a band of dwarves. Bilbo leaves the comfort of his pastoral home, travels to remote territories and encounters vicious creatures. Over the course of the novel, the hobbit develops courage and wisdom using his newly acquired thieving skills and his wit to solve riddles and escape from treacherous situations. The narrative's episodes are constructed around encounters, between different kinds of beings, that stem from the desire for food and/or precious objects. As such, the tale has been interpreted as one of overcoming greed and selfishness. The figure of the hobbit also provides a link to a simpler way of life and ancient knowledge, which serves Bilbo's crew well as they face extraordinary obstacles.

An interesting correlation between MacLeod's exhibition and the fantasy novel started to form as I thought about how the hobbit develops as a character, how he becomes brave and wise in his tumultuous adventure of self-discovery. This idea reminded me of a film MacLeod once described as a point of reference for her work: *Sullivan's Travels*—a 1941 American comedy written and directed by Preston Sturges. In the film John L. Lloyd Sullivan, a film director known for his lightweight comedies, sets off on a hobo's journey to discover poverty and suffering first-hand in the hope this will enable him to make a socially relevant drama. MacLeod discussed this movie in relation to a body of work she was creating that focused on the figure of the drunkard, a project that was also inspired by caricatures depicted in her impressive collection of postcards from the 1950s and 1960s.[1] These kitsch images show the drunkard as a fun-loving character, often dressed in bourgeois clothes, a representation of a tolerable and, at times, desirable escape from reality. In MacLeod's own words:

> My work deals with many of the same themes that appear in the film [*Sullivan's Travels*]: the conflict between art and commerce, the desire to make something "socially relevant," the struggle between popular entertainment and "high art," and, most importantly, the journey.[2]

The Hobbit and *Sullivan's Travels* are two very different narratives centred on male characters as they move beyond their "normal" lives and pretend to be something they are not: Bilbo was hired by the dwarves as a thief while Sullivan pretends to be a nomadic hobo. Through their respective journeys, encounters and lived experiences they ultimately become nobler versions of themselves.

Through the work presented in this exhibition MacLeod orchestrates a murky, challenging and at times

P. 28
The Tiny Kingdom, 2001
wood, mixed media
411.5 x 121.9 x 121.9 cm
Collection of the National Gallery
of Canada

Production photograph from *Chitty
Chitty Bang Bang*, 1968, with Grandpa
Potts and outhouse. © 1968 Metro-
Goldwyn-Mayer Studios Inc. All Rights
Reserved. Courtesy of MGM Media
Licensing.

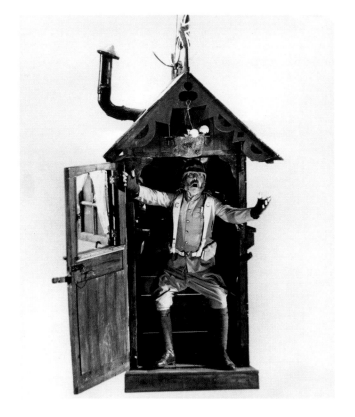

confusing quest of self-discovery that investigates aspects
of longing, repulsion and the cautionary tale. Seeing the
exhibition installed at the Museum London, I was struck
by the diversity of works and characters I encountered as
I navigated through this surprising and eclectic universe.
It was an unprecedented opportunity to see very different
bodies of work—from an outhouse that serves as an
unusual refuge, hex symbols painted on wooden panels, a
burnt out muscle car on a rotisserie spit, a grid of stacked
speaker cabinets and a child-sized mannequin dressed as a
ghost, to snowflakes cut out of posters depicting pop icons
and origami animals made from centrefolds of the model
Dorothy Stratten—and to witness the dialogue that emerged
between them. It became apparent that each of MacLeod's
works encapsulates an exploration in itself and, when
considered together, they map out a perilous odyssey, with
moments of comic relief, where one can easily get lost or
disoriented but can also reflect upon basic human impulses.
MacLeod has an ability to use her sculptures, photographs
and installations to analyze and satirize the relationships
between individuals and the (art) world as manifestations of
larger social structures. She has become known for her wry
sense of humour, which combines and distills references as
diverse as Minimalism, abstract painting, superstition, mass
entertainment, folk art and hillbilly life. MacLeod translates
images and ideas uprooted from popular culture and
vernacular realms to create her works; that is, she transforms
them into new configurations that have altered meanings in
the context of the museum or gallery.

 In her production, there is always a tension between
reality and representation as she appropriates from film,

art history, literature and popular or marginal cultures.
With *The Tiny Kingdom*, for example, she transformed the
outhouse from the 1968 film *Chitty Chitty Bang Bang* into
an architectural folly. This act shifted the representation
of the building from cinematic prop to tangible existence,
from concept to form. In the original film, which is set
in the 1910s, the inventor Caractacus, who lives with his
father and two children in a rustic farmhouse and windmill,

acquires an old car (aptly named Chitty Chitty Bang Bang) with extraordinary abilities, including flight. Upon hearing of the marvel, the ruler of Vulgaria, Baron Bomburst, orders the kidnapping of the inventor, but through mistaken identity the eccentric Grandpa Potts is captured instead. Grandpa Potts continually relives moments from the past, believing he is still a soldier fighting wars in faraway places. Throughout the film the outhouse becomes his refuge and a place where he can escape into a delusional state of mind. MacLeod's version of the structure, *The Tiny Kingdom*, acts as an unconventional shelter that becomes strangely associated with bodily functions. The artist strips away the building's function by turning the outhouse into a decorative folly, reminding us that it is not a real lavatory but a sculpture into which we can peer but not enter. *The Tiny Kingdom* can be considered a nod to Marcel Duchamp's infamous *Fountain*, wherein the artist displayed a urinal as a work of art and initiated the tradition of the ready-made. The piece is a prime example of MacLeod's conflation of references taken from popular culture, hillbilly life and art history.

Furthermore, *The Tiny Kingdom* has a political dimension and was conceived while MacLeod was working at the Canada Pavilion during the Venice Biennale. She became increasingly aware of the building's situation and architecture in comparison to neighbouring pavilions. BBPR, the Italian architectural firm responsible for the design of the Canada Pavilion (built from 1954 to 1958), sought to create a modest seasonal structure that corresponded with their philosophy of bridging the modern with the vernacular. In doing so, the Pavilion can be seen as a reaction to the monumental and imperialist impulses of architecture associated with Mussolini's Fascism and to the surrounding neo-classical pavilions: British (1909), French (1912) and German (rebuilt in 1938 under Hitler's orders). Canada's pavilion has often been described as a garden shed or out building subordinated to its imposing neighbours. For MacLeod, *The Tiny Kingdom* explores notions of colonialism embodied in the architecture of the Pavilion itself and its relationship to pavilions representing great colonial powers. According to MacLeod:

> *The Tiny Kingdom* is a sculpture that uses the vernacular architecture of the outhouse as a symbol of Canadian national identity. In its rustic folk form it is a kind of outpost that embodies some of my ambivalence and fears about our colonial origins. In this way, it addresses not only notions of subjectivity but also our innate desire to create kingdoms—which even when we do, as de la Montaigne says: "Even on the highest throne in the world, we are still sat on our backsides."

In keeping with MacLeod's exploration of vernacular architecture and identity, her *Hex* paintings look to a folk art tradition, associated with Eastern Pennsylvania Dutch culture, of marking the sides of barns and objects such as bibles and pottery with hex symbols.[3] While some claim the signs are mere decoration, others attest the symbols have very specific meanings and are believed to ward off evil spirits and bring forth a good harvest, good luck, faith, love and happiness. Intrigued by these traditional folk symbols, MacLeod translated them into artworks that could be deciphered and invested with different meanings when seen through an aesthetic and conceptual lens. In their

Donald Judd
Untitled, 1973
plywood
182.9 x 256.5 x 182.9 cm each rhomboid
National Gallery of Canada, Ottawa
© Donald Judd Foundation / SODRAC,
Montreal / VAGA, New York (2014)
Photo: © National Gallery of Canada

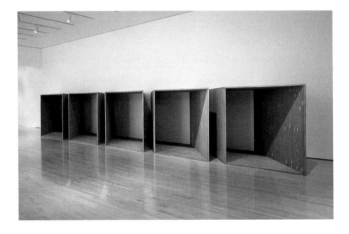

original state, the hex signs address both the individual's faith in an alternative belief system connected to working the earth and a collective ideal grounded in a strong sense of communal identity. The symbolism of the signs speaks to the wish for good weather and abundant crops as well as the desire for love, luck and happiness. For example, *Hex III* features an eight-pointed star ringed with a blue and green scallop, and at its centre, a multi-coloured rosette is set within a white circle. Traditionally, this sign stands for rain, sun, abundant crops and fertility. *Hex IV* is a take on the traditional Morning Star—a star for a bright day with six hearts standing for love and kindness for others. For *Hex V,* MacLeod depicts the tree of life, which harbours all the signs for a good life including smaller hex symbols for rain (swirl), love (hearts), good luck (rosettes), faith (tulips) and abundant crops (sun). In *Hex VII* the main element is a yellow and red distlefink, or good luck bird, on a blue background surrounded by a scalloped edge. The scallops symbolize smooth sailing through life and the circular form itself evokes infinity and eternity. The dark wood grain of each painting's support evokes the designs' original locations on the sides of barns.

MacLeod collaborated with a professional sign painter to produce the works. According to the artist: "My decision to have the works fabricated by someone else but according to my specifications is part of the ethos of Minimal art. By adopting this Minimalist strategy, I wished to sweep aside the vestiges of authorial presence manifested by formal invention and the handling of materials."[4]

With the *Hex* paintings MacLeod sets up a dialectical relationship between representational and abstract art.

The reduced geometric forms, the rigorous arrangement of elements and the prominence of the circle speak to abstraction, while the designs themselves read as figurative symbols imbued with their own stories, mystical content and associated beliefs. MacLeod states:

> The hex signs reveal parallels to modernist aesthetics, in their bold colour fields and simple abstracted forms. They are entitled, every bit as much as a Frank Stella or a Kenneth Noland, to lay claim to and participate fully in the aesthetics of modernism. But the collective nature of the works means that they are not valorized as an extension of the artist's persona. Even if the form of these "signs" speaks to Duchamp's renunciation of uniqueness of the art object, their content speaks to an exploration of the territory which lies between cultural sign and individuality.[5]

MacLeod doesn't denigrate what we generally consider to be "low" culture, but learns from different vernacular traditions, elevating them so that they can be considered on the same level as "high art"—and reminding us that art is also made by regular folks.

Upon reflection on the connections between *The Tiny Kingdom* and the *Hex* paintings, the marginal characters of the hillbilly (embodied in the figure of the slightly deranged Grandpa Potts) and the Pennsylvania farmers whose superstitions are manifested outside of the mainstream, I was surprised that *Everything seems empty without you*, a seminal piece that references hillbilly culture, was not included in the exhibition. Here MacLeod was inspired by an image of a functional homemade moonshine still in the backwoods of North Carolina, which she found in her collection of 1950s and 1960s postcards. Formally, the large installation of seven wooden boxes and four steel barrels (three black and one cadmium red) connected by metal pipes brings to mind Donald Judd's Minimalist sculptures, particularly the plywood boxes from the early 1970s. Like Judd's sculptures, MacLeod's work employs a serial arrangement of pristinely crafted wooden containers. But in contrast to the famed Minimalist's work, they appear to be made out of recycled wood and metal, and could be used as real containers, creating a tension between form, function and material. In a moonshine still, grain ferments, produces alcohol and releases fumes as it is processed from one receptacle to the next; each step purifies the contents until a potent liquid, free of most contaminants, is obtained. This process can be compared to modern art and specifically to Minimalist art making, where ideas and forms are distilled to their essence.

According to MacLeod, "*Everything seems empty without you* references kitsch, folk art and modern culture; it also attempts to work between tendencies toward the figurative and the minimal by embracing both the representational and referential in sculpture."[6] The piece is a complex merging of "high art" and "low culture." It oscillates between a representation of a functional still and an homage to the purity and logic of Minimalist form. What further confuses our experience of the object is the suggestive title that addresses the viewer in a personal, even loving manner. It is unclear if the sculpture feels empty without us or, inversely, if we feel empty without it. Or perhaps the sculpture longs to produce alcohol or we want to consume it. One thing is certain: the negative space or void that was seminal in Minimalist sculptures wants to be filled in MacLeod's work. According to the artist:

> … the work takes its name from another postcard from my collection, which depicts a ghostly silhouette of a beer stein cut out of burlap with the words "Everything seems empty without you" beside it. The title is an important part of the work as it evokes romantic feelings of solitude and alienation and suggests the longing for, but impossibility of communicating with another individual, especially when that person is no longer around.[7]

Making my way through the exhibition, the significant absence of *Everything seems empty without you* started to haunt me as I longed to consider that piece in relation to others that were in the exhibition. The sculpture

encapsulates ideas of the void and a desire to be whole, and as I considered the show these concepts, along with ideas of emptiness and loss, became increasingly visceral. Certain works particularly impelled me: *The Tiny Kingdom* as an asylum where one can fantasize, experience madness and evade reality; the hex symbols that evoke alternative modes of belief; and works from the series *Sullivan's Travels*, including the print *The Drunkard's Walk, or How Randomness Rules Our Lives* and *The Littlest Hobo*, a small-scale sculpture of a drunk walking on all fours up a flight of stairs, both of which deal with alcoholism as a form of escape. I was further spurred by *Ramble On*, a burnt-out 1977 muscle car emptied of its insides and hung on a portable rotisserie spit; a series of origami sculptures (*Splitting, Cormorant on a Rock, Shipwreck, Horse, Lover's Knot*, etc.), made from pornographic magazine centrefolds of the murdered Vancouver beauty Dorothy Stratten, and their photographic enlargements; and a disembodied voice recorded during a spinning exercise session that emanates from *Don't Stop Dreaming*, exhorting me to "Use your body, use your breath, use your mind" and "keep going." Feelings of melancholia slowly started taking me over; the objects were signifying a grave absence, a distinct void, a profound emptiness or remarkable disembodiment. The repeating recording of *Don't Stop Dreaming* started to enter into my psyche as I was continually pulled between the here and now and an imaginary landscape, as the trainer's voice suggested we were pedaling up or down a hill, while demanding that we commit to attaining our goal and breathe. The accompanying photographic mural of a forest landscape provided a way to visualize the described journey, which

here appeared as one of self-improvement, marking a clear disjunction between the mental image of a physical ideal and dream-like journey, and the actual state of the body grounded in the present.

A more extreme mutation of the body is evoked in the Stratten works, where the printed photographs of the model's body are transformed first into paper origami shapes and then into enlarged photographs of the paper sculptures. The fragile materiality of the centrefolds is heightened and the images from *Playboy* magazines are given a renewed physicality as we notice the staple perforations, the marks of handling and the scars of folding. Using traditional origami forms, MacLeod refolds the posters so that only sections of Stratten's body are visible, making it appear fractured and abstract. As viewers we are called to examine the subject, decode the information and decipher the fragments of the body. In this instance the relationship between form and subject is particularly interesting, as it evokes the tension between the impulse to control or contain and the slippages that occur when we recognize the pornographic origin of the image, which situates the female body as an object of desire. It also speaks to the notion of the abject and the grotesque as categories of the body; to the revealing of the body's interior, orifices and uncontained nature; and to the hybridity of the works as both transfigured bodies and tactile objects. MacLeod's interest in these concepts extends as well to the figure of the drunk, which evokes the idea of excess and encapsulation in the out-of-control body, and to *The Tiny Kingdom*, which suggests bodily functions and fluids. Through these moments of slippage, the role of control or constraint in many of MacLeod's other works and

the tension between formalism and the figurative become increasingly apparent.

Using the display of artifacts, found materials and repurposed forms, *The Tiny Kingdom*, *Hex II–VIII*, *The Drunkard's Walk, or How Randomness Rules Our Lives*, *Ramble On*, the series of origami and *Don't Stop Dreaming* describe moments and people from another time, struggles to attain an ideal form, objects of desire and an escape from the everyday. These various objects speak to human behaviour and evoke a longing for something lost. As I walked around in the museum I became fascinated with two almost imperceptible statements written in a decorative Gothic font that appeared on facing black walls: "Lost Inside" and "The Emptiness." They were a manifestation of my state of being—it seemed as if they stemmed from my consciousness and slowly became a peculiar mantra. I was left to reflect on how we live in a fast-paced, competitive and increasingly globalized Western society where emptiness and loss are considered negative conditions to be alleviated through endless consumption. We are continually conditioned to "fill" these voids, the feelings of loneliness, of disappointment, anger, hurt and pain, to numb them through substance abuse, excessive exercise, religious belief, social withdrawal, entertainment and sex. In certain Eastern belief systems such as Buddhist philosophy and Daoism (Taoism), emptiness and nothingness are goals to be attained to liberate one's self from the ego, attain purity of mind and generate personal growth. The Daoist teacher Lao Tzu reminds us:

> We put thirty spokes to make a wheel: but it is on
> the hole in the centre that the use of the cart hinges.

> We make a vessel from a lump of clay; but it is the
> empty space within the vessel that makes it useful.
> We make doors and windows for a room; but it is
> the empty spaces that make the room livable. Thus,
> while existence has advantages, it is the emptiness that
> makes it useful.[8]

A number of works by MacLeod embrace emptiness and absence, making us aware of their essential (although feared) presence in our lives. A case in point is *Everything seems empty without you,* where the artist uses a moonshine distillery to bring together the DIY process of producing alcohol associated with hillbilly culture with strategies borrowed from modern art, and more specifically Minimalism, where ideas and forms are distilled to their "pure" essence. MacLeod's works can also be interpreted as cautionary tales about the trappings of substance abuse, obsessive activity and escapism. By investigating these sensitive subjects she points to larger social ills and unsettling human behaviour. Through her exhibition *Myfanwy MacLeod, or There and Back Again*, she reminds us that the journey of self-discovery is not an easy one; it is littered with encounters of strange, if not dubious, characters and difficult obstacles to overcome.

Endnotes

OPPOSITE
The Last Drop, 2013
bronze, GFRC log, glass bottle
931 x 1504 x 1082 cm
Courtesy Catriona Jeffries Gallery

1 I discuss the *Sullivan's Travels* body of work in more detail in the publication
 Nomads (Ottawa: National Gallery of Canada), 2009.
2 Myfanwy MacLeod quoted in *Nomads*, 2009, p. 19.
3 They are also found in counties in Virginia and Pendleton counties, West Virginia.
4 The artist in an unpublished essay.
5 Ibid.
6 Ibid.
7 Ibid.
8 Lao Tzu (ca. 604–531 BC), www.inspirationalstories.com, accessed September 25,
 2013. Interestingly, Lao Tzu, considered to be the first Taoist, decided to leave
 society to pursue a life of contemplation as a hermit in the wilderness.

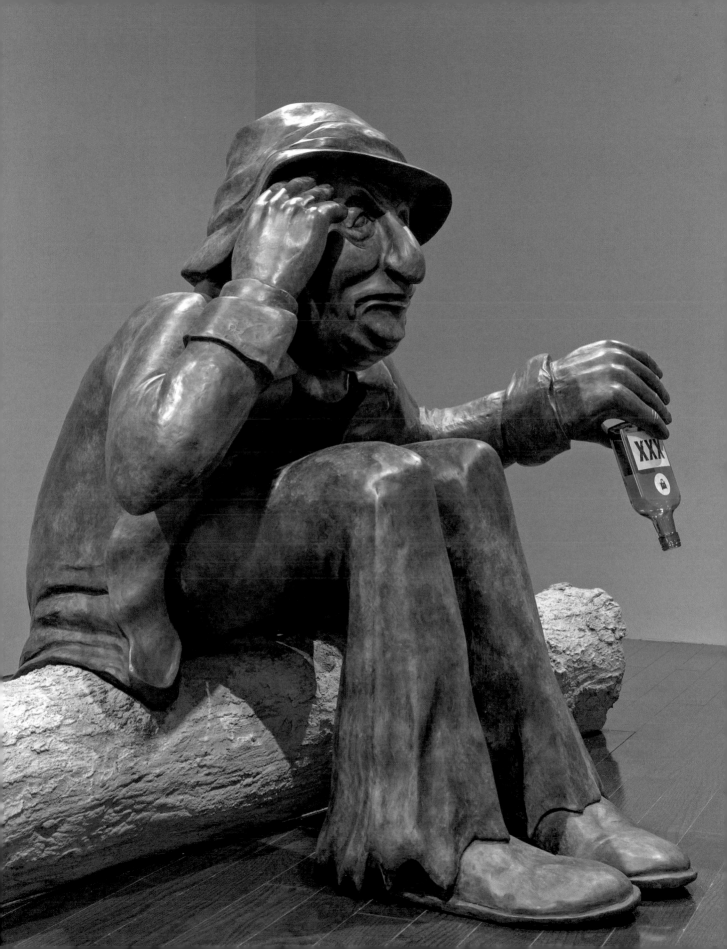

38

Everything seems empty without you, 2009
(detail)
painted metal oil drums, steel rack,
painted steel pipes, brushed aluminum,
wooden boxes, wooden barrel
299.7 x 843.3 x 238.8 cm
Collection of the National Gallery
of Canada

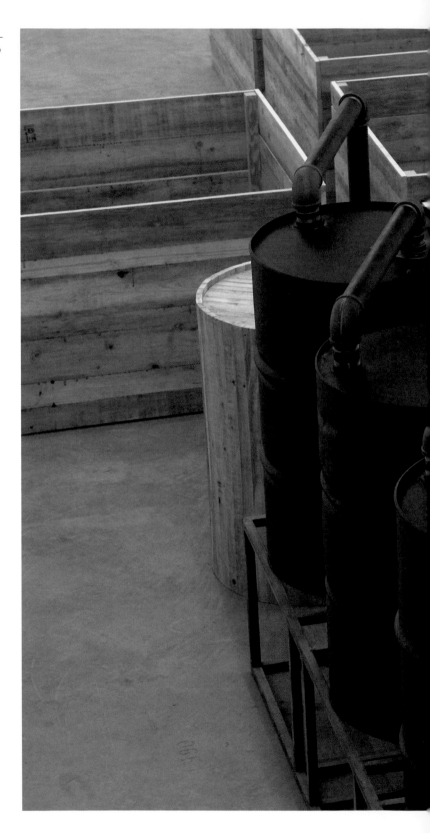

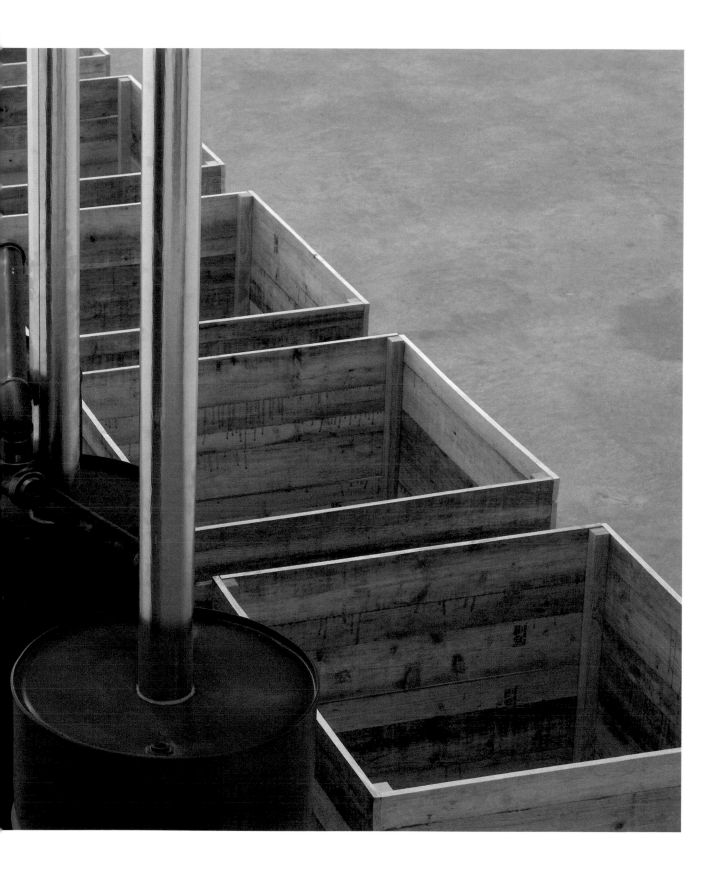

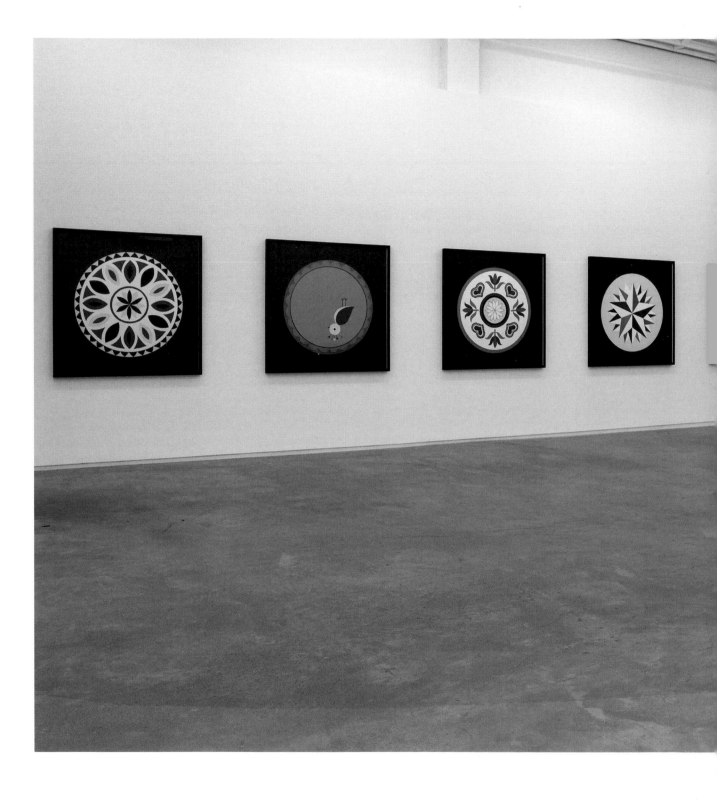

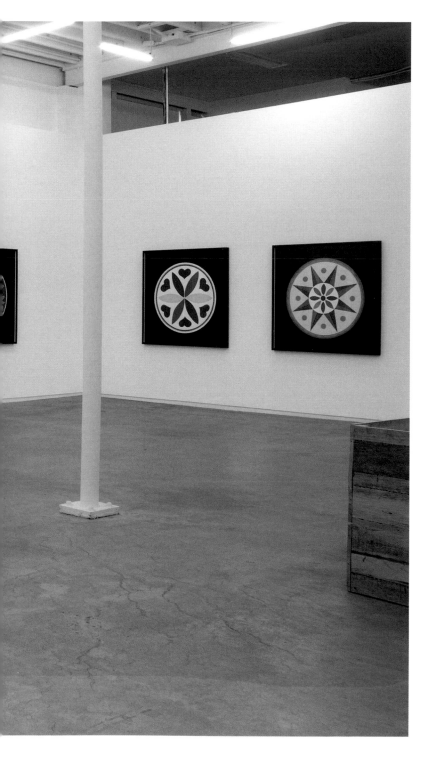

Installation view of *Hex* paintings,
Catriona Jeffries Gallery, Vancouver, 2009

Hex IV, 2009
enamel on wood
122 x 122 cm
Collection of the National Gallery
of Canada

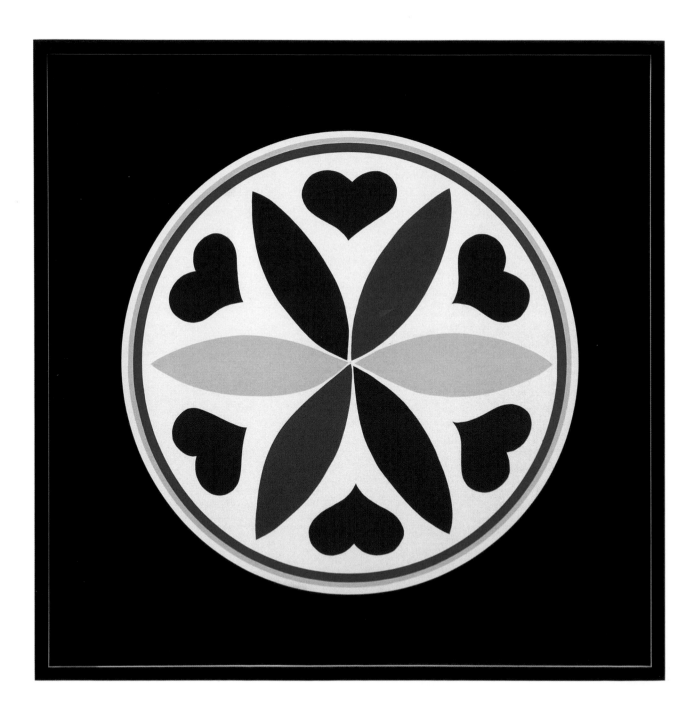

Hex V, 2009
enamel on wood
122 x 122 cm
Collection of the National Gallery
of Canada

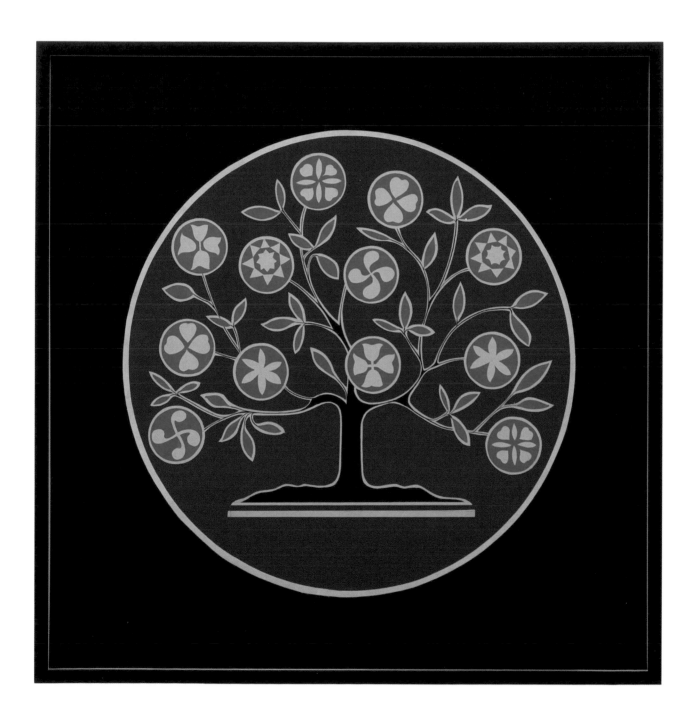

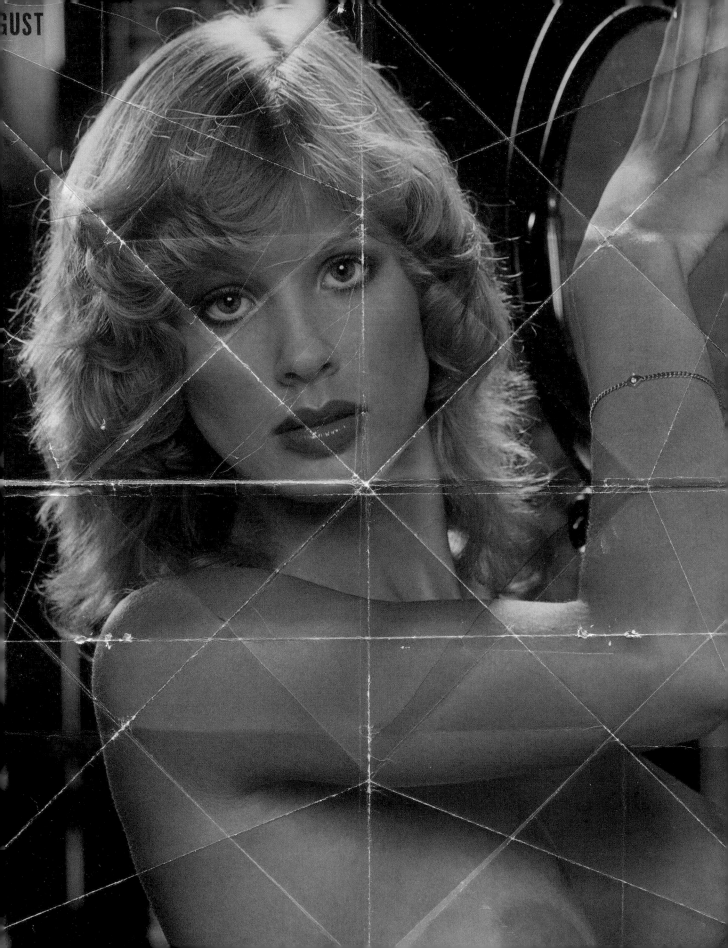

IN THE ABSENCE OF PRESENCE

Joseph Monteyne

Modernity, according to Martin Heidegger's discussion of poetry and Friedrich Hölderlin, is characterized as a moment "in the no-longer of the gods who have fled and in the not-yet of what is to come."[1] In a period of increased secularization, the poet is forced to interrogate the historical and ontological essence of art and the religious function of the artist as an intermediary between people and gods. He or she engages in the production of art at a moment paradoxically characterized by the absence of ancient gods but nonetheless in advance of the gods to come. Heidegger was grappling with the unusually central position that art assumed with respect to other forms of culture in the epoch of metaphysics and at its end. For example, the mythic figure of the artist could only be understood in the framework of a culture in which religion has been replaced by art. Furthermore, as the notion of religion was emptied out during the modern age and art responded with a loss of substance, the sacred became increasingly remote from the perspective of the masses now enthralled by the realm of kitsch. As Gianni Vattimo has written, during the twentieth century a critical and militant aesthetics opposed kitsch to an avant-garde affirmation of the purity of art that verged on aphasia. In contrast, an "aesthetics of a hermeneutic inspiration" would prove itself to be more attentive to the social existence of art, and especially to aspects of mass art such as rock music and its modern gods.[2] Such an approach might also allow for the recognition of a link that the phenomenon of secularization maintains between aesthetic experience and religious tradition. Here one would be able to interrogate, for example, the phenomena of identification and experience of community that is found today in the form of popular music concerts, as well as be attentive to a concomitant enfolding of collective adoration and a legacy of idol worship. I see these lines converging in recent work by Myfanwy MacLeod and this, it seems to me, is a reflection of a new seriousness and exploration of melancholy that took root after she participated in the Glenfiddich residency in Scotland.[3] As noted by Jenifer Papararo and Francis McKee, works produced by MacLeod as a result of her sojourn in the north of Scotland, such as those that reference ghosts, speak to an interest in the absent presence of spirits and a desire to play with the line between the sacred and the secular.[4] This is what gives MacLeod's work a resonance not seen in the output of other contemporary artists who have been fascinated with rock or heavy metal culture.

Take, for example, the work *Presence*, which the artist herself states is one of the works in this exhibition that explores the relationship between minimal art and heavy metal music, especially that of Led Zeppelin. *Presence* is, of course, the title to Led Zeppelin's seventh album, released in 1976, in which the power and presence of the band's sound was represented by a black object (actually referred to as "the object") featured in images on the album's cover, which was designed by Hipgnosis.[5] One thousand of these sculptures were actually made as a limited and numbered edition when first released. This thing represents a fusion of minimalist art and the esoteric mystical symbolism of a similar object in Stanley Kubrick's *2001: A Space Odyssey* (1968), where it appears as an anachronism, ambiguously worshipped by primates as a remnant of the past in a new post-apocalyptic present, or a harbinger of the future from another dimension

46

P. 44
Miss August, 2012 (detail)
creased Dorothy Stratten *Playboy* poster,
flocked matte board, Plexiglas
54 x 54 x 5 cm
Collection of Jane Irwin and Ross Hill,
Greychurch

Installation view of *The Jet Set*, 2013 and
Presence, 2013

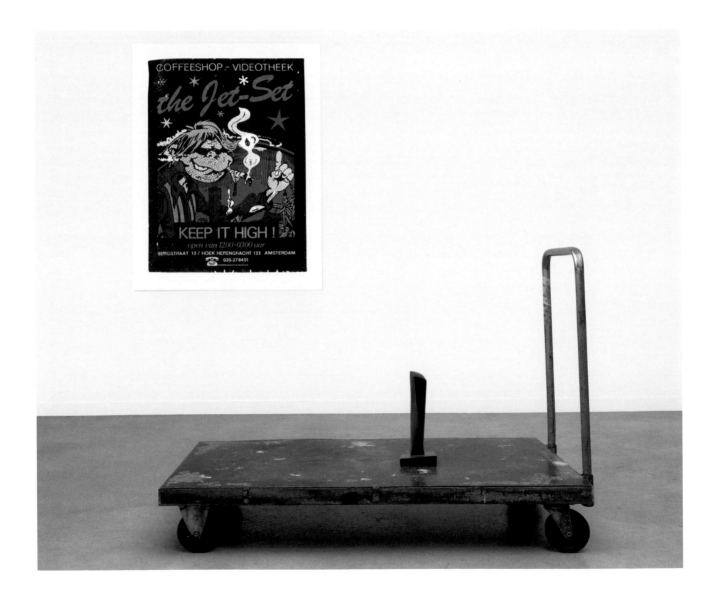

but rooted in a pre-historic era. An evocative but melancholic moment of the gods that have fled and the gods still to come is signified, it seems to me, by this object.

In the photos on the *Presence* album cover, the object also acts as an anachronism. Its sleek black shape is inserted into a variety of scenarios that evoke nostalgia for post-war ideals. The sculpture appears in the middle of a table where it is contemplated or prayed to by a perfect nuclear family, in a mountain meadow where a young girl dreamingly caresses it and in a 1950s-style classroom where a teacher tries to channel some of its power into the head of a young boy. Other photos represent the secularization of this thing, with attempts to record, measure, analyze or safeguard it. It is striking, however, that in these photos the object has been retouched so that it actually represents an absence. The sculpture at the centre of these different scenarios is in fact a flat and dark void without detail. It is a literal visualization of the definition of presence as something felt but unseen. But this is also what the Greeks called an *eidolon*, an image lacking in material substance. Such an image can be seen but not touched; it is fully articulated in form, clearly outlined but devoid of tangible matter, and was initially the form a god (or a ghost) took when it appeared.[6] Thus, the object is an empty sculptural idol poised somewhere between vanishing and appearing, in the same way that MacLeod's *Torso of a Young Girl* (2006), prompts viewers to wonder whether the wig represents the last part of the girl to disappear or the first to emerge as her presence manifests.

Depending on your perspective, then, idols are often not gods but demons and Macleod's materialization of *Presence* in relation to the mirror of Dr. John Dee—the

Elizabethan mathematician, astrologer and explorer of psychic phenomena—reminds us of Jimmy Page's own interest in the dark arts.[7] Page, as is well known, was interested in the work of Aleister Crowley and owned the occultist's former residence Boleskine House. Crowley, in one of his manifestations, claimed to be the reincarnation of Edward Kelly, a medium or "scryer" that Dee began working with after 1583.[8] Some Led Zeppelin fans interpret the small figure included in the lower corner of the original *Stairway to Heaven* lyric insert as an image of Dee, his head tipped down to look at a weighty tome while some mystical inscriptions appear behind him.[9] Dee and Kelly practised what they called "Angelic" magic, a form that has come to be called "Enochian."[10] Revived and incorporated into the rituals of a secret brotherhood in nineteenth-century England called the Hermetic Order of the Golden Dawn, this form of the occult is what Crowley practised, wrote about and popularized in the early twentieth century.[11]

Dee's mirror—polished, translucent, reflective—was made from obsidian, a form of black volcanic glass. It is now in the collection of the British Museum and it is believed to have originated from Mexico, where it was almost assuredly an Aztec cult object.[12] Dee studied in Louvain when the Spanish ruler Charles V regularly held his court there, and many such objects from the recently conquered Aztec Empire came into the possession of Spanish courtiers.[13] Black obsidian mirrors were associated with Tezcatlipoca, the Mexican god of rulers, warriors and sorcerers. Tezcatlipoca was a shape shifter, associated with darkness and shadows, in addition to being the god of all material things. He brought destruction and chaos, but could also bestow important

gifts. His name actually means smoking mirror, and in Aztec pictographs he was depicted with such an object above his head or attached to his snake-like foot.[14] Aztec royalty used these mirrors as symbols of power and priests employed them to communicate with the spirits of the dead. Dee would have been drawn to devices like this that were supposedly used in divinatory practices, and during experiments he and Kelly would see angels reflected in the mirror. These beings would reveal magic squares and esoteric symbols famously transcribed by Dee.

It was not just the Aztecs, however, who were attracted to the qualities of obsidian, since the Romans too valued it for its reflective powers. Pliny the Elder, in *Natural History,* intriguingly commented that this stone's polished surface "reveals the shadows of objects much more than the objects themselves."[15] This association of the mirror with the shadow has a long legacy in Western thought and Christianity. Pliny also considered the shadow crucial to the origin of pictorial representation in the myth of Butades, a potter who made a three-dimensional image of his daughter's departed lover from an outline of his shadow that she had traced on a wall. According to Victor Stoichita, in this myth the primary purpose of making an image based on a shadow was its use as a mnemonic aid in a propitiatory ritual "of making the absent become present."[16] The shadow, however, was ultimately given a different reading in the history of art and philosophy as occupying the position of a fundamental negativity, of absence only, of that which is the farthest away from truth. This we owe to the myth of Plato's cave, wherein the shadow is displaced by the invention of an oculocentric culture in which the desire to see is equated with the desire to know.[17]

Thus, Medieval mirrors either reflected a light-filled divine model or, when they replicated only shadows, they were used by Satan to deceive with sinister lies and dark seductions. It is surely the connection of the mirror to the shadow, or the bodiless *eidolon*, that contributed to the Medieval characterization of it as the tool of the devil, an object into which demons could be locked. Mirrors, due to their very form and material, attracted "crazed stares;" they fed both the illusions of mind and the caprices of lust.[18] The church condemned divinations, conjurations and enchantments associated with the mirror—called "catoptromancy"—and they opposed all experiments with these objects. For example, the thirteenth-century Bishop of Paris, William of Auvergne, argued that reflection triggers a trance and that the brilliance of a mirror prevents an

onlooker from fixing his or her gaze on anything else. With attention captured, blinded and turned inward, the beholder would begin to perceive supernatural communication, occasionally from God, but most often from the Devil.[19] What, in truth, represented its greatest threat? The greatest sin of the mirror is that of fabricating mirages and providing a simulacrum of creation. It replaced divine reality with a deceptive world, and as such the mirror shared the era's condemnation of the art of painting—its reflection was a superficial imitation, a deception instead of a truth.

Although there is no mirror involved, we can see something similar transpire with *Stack*. This work owes to the stacking endemic of Minimalist installations, to be sure, but returns to figuration by presenting the viewer with the image of a Marshall stack. Like the black obelisk in *Presence*, another heavy metal icon appears. Jim Marshall (who passed away as this was being written) developed the Marshall amplifier and speaker cabinet in London during the early 1960s in response to a need for more volume and greater portability, since rock bands were playing larger venues and embarking on longer tours. As a backdrop for bands, the Marshall stack became an aural and visual symbol of arena rock's power and excess. Like an ancient icon, reproduction and multiplication of the Marshall cabinet led to an increase in the spiritual presence and authority of rock music's new secular gods. It is much discussed now, however, that these stacks were and are utilized by many bands solely for visual effect. Empty cabinets, even entire facades, are regularly sold on eBay and there are typically any number of discussion threads about this topic on websites such as mylespaul.com and marshallforum.com. For example, a particularly

damning photo of the black metal band Immortal was circulated amongst these sites. Taken from backstage, the photo revealed the band playing at an outdoor festival in front of a wall of empty cabinets. It is striking to me how these discussions represent a secularized version of classical debates about ancient images of the gods, debates structured around two positions—whether the gods were present in their images or absent. As might be expected, MacLeod clearly takes the skeptical position in this dialogue: behind the gods of rock and the heroic creators of Minimalist sculpture is literally a physical and material void. The Marshall stack is like the statues described in the Hellenistic *Batrachomyomachia* (Battle of the Frogs and the Mice), a third-century-BC parody of the *Iliad*: they are images of inner corruption, hollow inside and fit places for mice and other vermin to nest and nibble away at their very substance.[20] As the photo of Immortal clearly shows and MacLeod's *Stack* perceptively suggests, these are the empty idols behind modernity's new gods. In this evocative parody of Minimalist art and male fantasy there is no presence, only absence; no depth, only surface.

Departing somewhat from rock music, but still rooted in the domain of male fantasy, the Dorothy Stratten series of centrefolds transformed by origami in a process of *détournement* are also visually seductive and deceptively simple works. In typical MacLeod fashion there is a literal play on words, in that origami, the art of folding paper, is applied to photographic centrefolds taken from *Playboy* magazine. Now, since origami is supposedly best seen in a kind of light the Japanese call *ke*, the soft light of intimate occasions, these works make reference to the private

Gimme Sunshine, 2011
Dorothy Stratten pin-up poster, flocked
matte board, Plexiglas
70 x 70 x 13 cm
Collection of Andrea Thomas-Hill

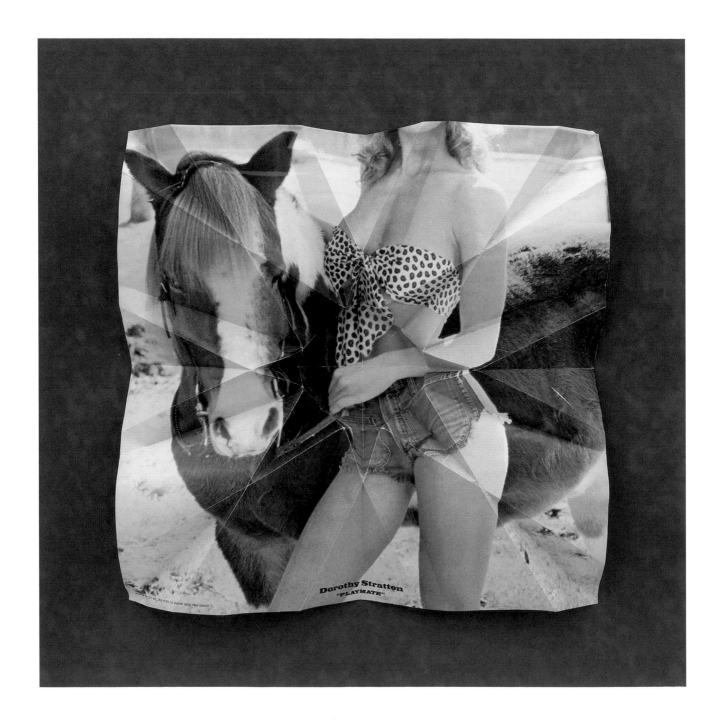

moments of desire in which these images of the Playmate would originally have been seen.[21] As developed by Hugh Hefner and the staff of *Playboy*, the centrefold was designed to evoke a "reality effect" by using recognizable settings and props suggestive of an actual circumstance. In Hefner's instructions to a photographer, the camera was expected to act as "our guy who is present but unseen," so that the reader/viewer of the magazine's photos could identify with the invisible masculine company in order to suggest a private intimate exchange.[22] Thus this absent presence, felt but not seen, is intended to be the anonymous male viewer whose erotic experience is also contingent on a process of physically reorienting the magazine from horizontal to vertical and unfolding the image along the prescribed lines in order to reveal the nude body at the centre. And just how prescribed were these lines? *Playboy* photographer Arny Freytag, in an interview with Mark Edward Harris in 2002, revealed the constraints under which the centrefold was conceived: the format itself was restrictive, being "long and narrow," and "we're also limited by where the fold marks go." In the end "the centrefold shot is a product shot, in the sense that the model can't move around."[23]

According to Elisabeth Bronfen, the centrefold body is always already a "gesture of contortion," an artificial anagrammatic body distorted by forced unnatural poses. Furthermore, the pin-up is "an apotropaic charm against corporeal mutability," a representation of wholeness contradicted by any actual bodily experience, an image in which the body's irregularity is defied by being displayed as pure surface.[24] It has been suggested that the work of other female artists who have engaged with the cultural form of

the centrefold—Cindy Sherman's series of photographs commissioned and rejected by *Artforum* in particular—has highlighted an awareness of the vulnerability and volatility of the body.[25] Sherman's centrefold series uses mimicry to evoke the "subject under the gaze," presenting mirror masks that reflect the male viewer's desire to fix women in stable and stabilizing identities.[26] Her work is not about female subjects, but about questioning, destabilizing or even challenging the male discourses and gazes that function to objectify and constitute women.

MacLeod appropriates a photograph of Dorothy Stratten caught within a web of stereotypes, a "flattened cardboard imitation of character" as Rosalind Krauss might call it, and subjects the image to her own gesture of contortion at the level of materiality. But MacLeod's superimposition of origami upon these pictures—of fold upon fold as in *The Unicorn* and *Gimme Sunshine*—is positively Moorish, following the mode of this art brought to Spain by Muslim North Africans in the eighth century. As such, her technique resembles an "Islamic tessellation of the square."[27] This is paper folding instilled with geometry instead of figuration. Thus, MacLeod does not begin with a blank sheet of paper and fold towards a recognizable object in the Japanese style, but actually begins with the figure of Dorothy Stratten and deforms it through geometry. Here the beauty of Venus codified by the cultural institution representing male desire, Hefner's *Playboy* magazine, is effaced by a different form of beauty, one represented by the mathematician's economical regularity, pattern and order. This is not to say that the latter transcends the former, since both aspects are still visible, but that they are immanent with each other.

"Love Knot," engraving from John
Mennes, *Recreations for Ingenious Head-
Pieces* (1683). 15476.205.10, Houghton
Library, Harvard University

It is well known that Gilles Deleuze used the example of
origami in *The Fold: Leibniz and the Baroque* as an example
of his anti-Cartesianism, grounded in expression and
emblematized by the fold.[28] Substance folds, unfolds, refolds
and being is univocal. There is no distinction between layers,
levels or types of being; there is no transcendence, only
immanence. The universe is treated as if it were origami,
displaying the endless capacity of matter, space, time and
subjects to fold back upon themselves. Following Deleuze,
origami has been called "the exemplary art of spatial science"
in which "a folded thing always opens up to (an experience
of) infinity."[29] This is an experience, I might add, that a
religious worshipper was to feel in the presence of a god, be
it in the form of an *eidolon*, an animated statue or a mythic
creature—as the unicorn in the title of MacLeod's work
might suggest. In this regard, it is also worth pointing out
that origami is comprised of the Japanese words *ori* (to fold)
and *kami* (paper), but *kami* is also a homonym for "spirit" or
"god."[30] Thus, this is folded paper, but in being refolded by
the artist in this manner we become acutely aware that this
is also a folded goddess, one whose divine presence, in truth,
relies on the fold.

The composition of folds is not what something is, but,
as Deleuze tells us, what it is in the process of becoming.
The fold is never finished.[31] In this way, folds challenge
traditional accounts of subjectivity that presume a simple
dichotomy between interior and exterior, appearance and
essence, or surface and depth. What I find so striking here,
however, is that Japanese origami was historically a female
activity, practised primarily by young women. Before the era
of printed instructions, origami was a practice transmitted

162 *Fancies and Fantasticks.*

These may be read two or three wayes

Your face	Your tongue	yo
so fair	so smooth	so
first drew	then mov'd	the
mine eye	mine ear	my
Mine eye	Mine ear	My
thus drawn	thus mov'd	thu
affects	hangs on	yie
Your face	Your tongue	you

These may be read backward or forwar

Joy, Mirth, Triumphs, I do defie,
Destroy me Death ; fain would I dye:
Forlorn am I, love is exil'd,
Scorn smiles thereat ; hope is beguild:
Men banish'd bliss, in woe must dw
Then Joy, Mirth, Triumphs all farev
T.

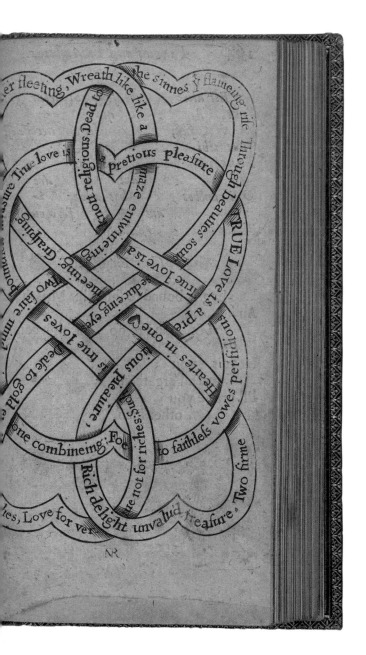

along a matrilineal line as designs were passed from mothers to daughters.[32] This is a gendered aspect of origami's history that remains invisible to Deleuze and his followers, who see it as a model to challenge notions of Cartesian subjectivity.

I understand the risks of essentializing vision along gendered lines here, but it is worth thinking of the contrast created by a feminine practice of folding applied to the male-oriented form of the centrefold. As a female artist, MacLeod annihilates prescribed folds and works within dominant paradigms of visuality and desire in order to create a wholly new series of folds that exert a dynamically different way of seeing. To see is not to replicate the fantasy of a subject possessing an object, as the unmanipulated centrefold articulates. Seeing becomes, rather, the acknowledgment of a possible world created in the fold between a material that receives the imprint of the world and the incorporeal or immaterial aspects of our own subjectivity.[33] MacLeod's paper sculptures almost suggest that experience and the production of art can only take place, as it does with Maurice Merleau-Ponty, in the fold between the sentient and the sensible.[34]

In *The Lover's Knot* subgroup of this series, the de-territorialized centrefold is re-territorialized as a knot. Being made to twist and fold in on itself further destabilizes the image. As the pin-up photo becomes more three-dimensional and closer to the Japanese mode of origami, it undergoes a total distortion—there is no up or down, no beginning or end, no recto or verso. These works call to mind early modern lovers' knots such as that reproduced in the 1683 edition of John Mennes' *Recreations for Ingenious Head-Pieces*. Language becomes a visual tangle in this image, as a banderole with words representing a love poem interlaces to form a

series of heart shapes reminiscent of a Borromean knot. A small heart appears on the band near the centre in the form of a *mise en abyme*, and an upper case "TRUE" is placed near the upper right edge, suggesting places to begin or end one's reading. However, this is quickly revealed to be an illusion. There is, in fact, no beginning or end, and even though the image demands physical manipulation in order to correctly situate the words, the reader/viewer simply cannot get oriented in relation to this work. Akin to the word games on the page opposite, the lover's knot destabilizes language and can be read in innumerable ways. In like manner, MacLeod twists the Stratten image into a knot, upsetting the dominant regime of vision as commodified desire and undoing the hierarchy of possessive male viewer and objectified female posited by the centrefold. As with Mennes' ingenious recreation, there is no beginning or end, no up or down. There is only a multiplicity of folds.

1 Martin Heidegger, "Holderlin and the Essence of Poetry," 1936, in Günter Figal ed., *The Heidegger Reader* (Bloomington: Indiana University Press), 2009, pp. 117–129. The citation is from p. 128.
2 Gianni Vattimo, *Beyond Interpretation: the Meaning of Hermeneutics for Philosophy* (Redwood City: Stanford University Press), 1997, p. 72.
3 As revealed in the interview with MacLeod conducted by Connie Butler for the exhibition catalogue *Where I Lived, and What I Lived For* (Contemporary Art Gallery: Vancouver), 2006.
4 See Jenifer Papararo, "New Icons of the Pastoral," p. 7; and Francis McKee, "An Empire of Ruins," p. 43, both in *Where I Lived, and What I Lived For.*
5 The object was also featured on the cover of *Frieze*, 37, Nov–Dec 1997, accompanied by an article from James Roberts entitled "Hipgnotic Suggestion," which included a discussion of the album cover designs of Hipgnosis.
6 Moshe Barasch, *Icon: Studies in the History of an Idea* (New York: New York University Press), 1993, p. 26.
7 MacLeod's interest in the mirror also seems to have begun at the Glenfiddich residency, as seen in *Princess X,* which appeared in the exhibition *Where I Lived, and What I Lived For,* in which a mirror was positioned to reflect one of the works of the ghost series.
8 Stephen Skinner ed., *The Magical Diaries of Aleister Crowley* (Newbury: Weiser Books), 1996, p. 4.
9 Mick Wall, *When Giants Walked the Earth: A Biography of Led Zeppelin* (London: Orion Books), 2008, p. 259.
10 John Dee, Edward Kelly and Donald Laycock ed., *The Complete Enochian Dictionary: A Dictionary of the Enochian Language as Revealed to Dr. John Dee and Edward Kelly* (Newbury: Weiser Books), 2001, p. 65.
11 For further details see Tobias Churton, *Aleister Crowley: the Biography. Spiritual Revolutionary, Romantic Explorer, Occult Master—and Spy* (London: Watkins Publishing), 2011.
12 Silke Ackermann and Louise Devoy, "'The Lord of the Smoking Mirror:' Objects Associated with John Dee in the British Museum," *Studies in History and Philosophy of Science Part A*, 43:3, 2012, pp. 539–549.
13 See H. Tait, "The Devil's Looking Glass: the Magical Speculum of Dr. John Dee," Warren Hunting Smith ed., *Horace Walpole: Writer, Politician, and Connoisseur* (New Haven: Yale University Press), 1967, pp. 195–212.
14 Serge Gruzinski, *Painting the Conquest* (Paris: Flammarion), pp. 9 and 64.
15 Cited in Sabine Melchior-Bonnet, *The Mirror. A History* (Abingdon: Psychology Press), 2002, p. 12.
16 Victor I. Stoichita, *A Short History of the Shadow* (London: Reaktion Books), 1997, p. 15.
17 Stoichita, *A Short History of the Shadow,* p. 24.
18 Melchior-Bonnet, *The Mirror,* p. 187.
19 Melchior-Bonnet, *The Mirror,* p. 189.
20 Barasch, *Icon: Studies in the History of an Idea,* pp. 54–55.
21 Peter Engel, *Origami from Angelfish to Zen* (Mineola: Courier Dover Publications), 1994, p. 23.
22 Carrie Pitzulo, *Bachelors and Bunnies: the Sexual Politics of Playboy* (Chicago: University of Chicago Press), 2011, p. 47.
23 Mark Edward Harris, "Anatomy of a Centerfold," *American Photo*, March/April 2002, pp. 58–61.
24 Elisabeth Bronfen, "Chuck Palahnick and the Violence of Beauty," in Zoe Detsi-Diamanti et al eds., *The Future of the Flesh: A Cultural Survey of the Body,* 2009 (Basingstoke: Palgrave Macmillan), pp. 103–104.
25 Bronfen, "Chuck Palahnick and the Violence of Beauty," p. 108.
26 The literature on Sherman is vast and one cannot do it justice here. This particular reading of Sherman emerged primarily from a group of writers associated with *October* magazine. See, for example, Douglas Crimp, "The Photographic Activity of Postmodernism," *October* 15, Winter 1980, pp. 91–101; Rosalind Krauss, "A Note on Photography and the Simulacral," *October* 31, Winter 1984, pp. 49–68; Craig Owens, "The Discourse of Others: Feminists and Postmodernism," in Hal Foster ed., *The Anti-Aesthetic: Essays on Postmodern Culture,* 1983, pp. 57–82; and Hal Foster, "Obscene, Abject, Traumatic," *October* 78, Autumn 1996, pp. 106–124.
27 Engel, *Origami from Angelfish to Zen,* p. 30.
28 Gilles Deleuze, *The Fold: Leibniz and the Baroque* (Minneapolis: University of Minnesota Press), 1993, p. 6.
29 Marcus Doel, *Poststructuralist Geographies: the Diabolical Art of Spatial Science* (Lanham: Rowman & Littlefield), 1999, p. 161.
30 John Montroll, *Origami Sculptures* (Mineola: Courier Dover Publications), 1990, p. 8.
31 Deleuze, *The Fold,* p. 34.
32 Robert J. Lang, *The Complete Book of Origami* (Mineola: Courier Dover Publications), 1989, p. 1.
33 Simon O'Sullivan, "Fold," in Adrian Parr ed., *The Deleuze Dictionary* (Edinburgh: Edinburgh University Press), 2005, pp. 102–106.
34 See, for example, Maurice Merleau-Ponty, "Eye and Mind" and "Cezanne's Doubt," in Michael B. Smith ed., *The Merleau-Ponty Aesthetics Reader: Philosophy and Painting* (Evanston: Northwestern University Press), 1993, pp. 59–75 and 121–149.

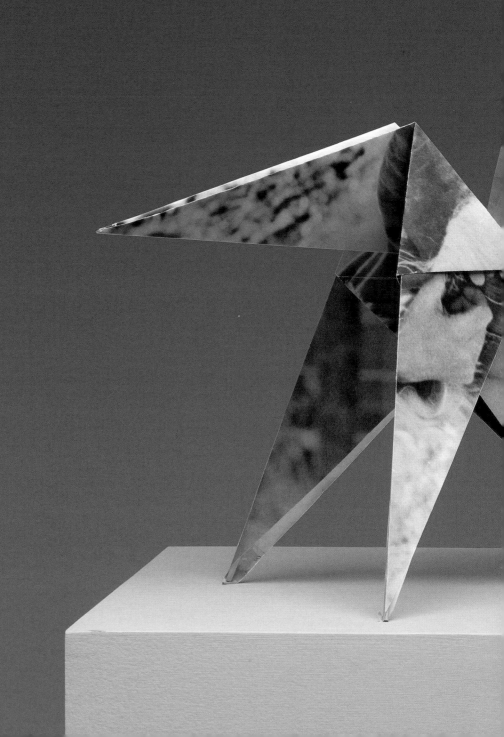

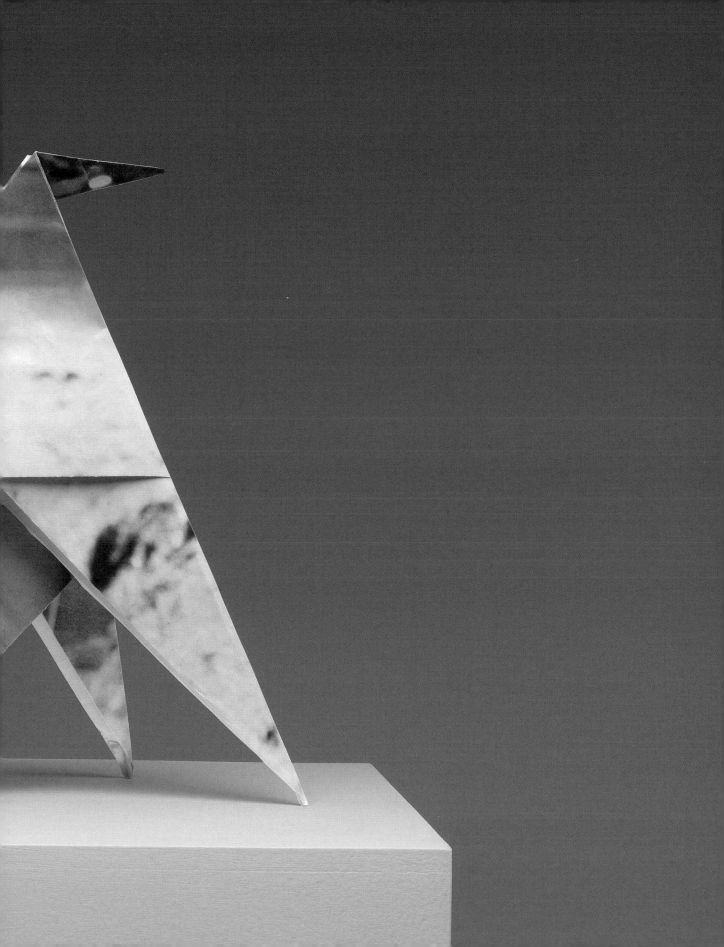

PP. 56–57
Horse, 2012
Star City pin-up poster of Dorothy
Stratten
38 x 26 x 20.25 cm
Courtesy Catriona Jeffries Gallery

Parrot, 2012
Star City pin-up poster of Dorothy
Stratten
54 x 11.5 x 25.4 cm
Courtesy Catriona Jeffries Gallery

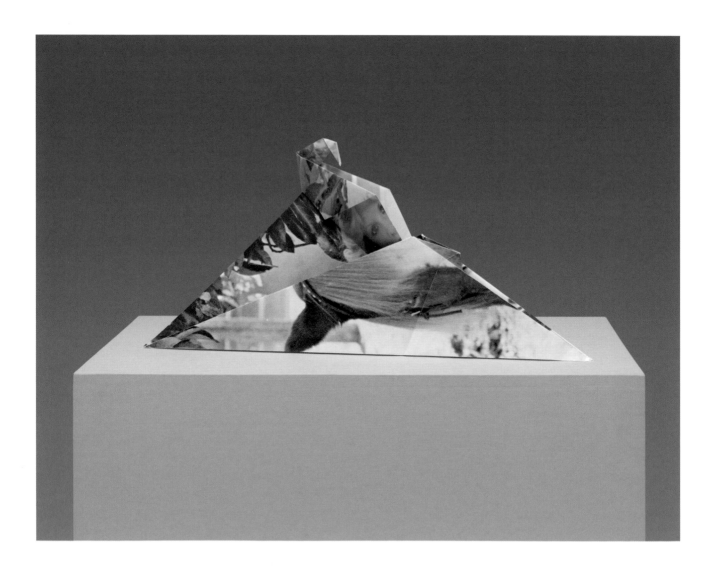

Lover's Knot, 2012
Star City pin-up poster of Dorothy
Stratten
24.4 x 19 x 25 cm
Courtesy Catriona Jeffries Gallery

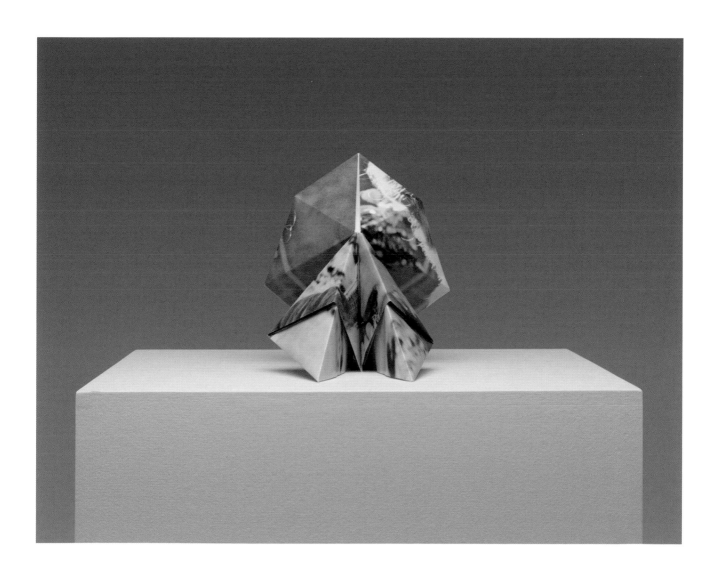

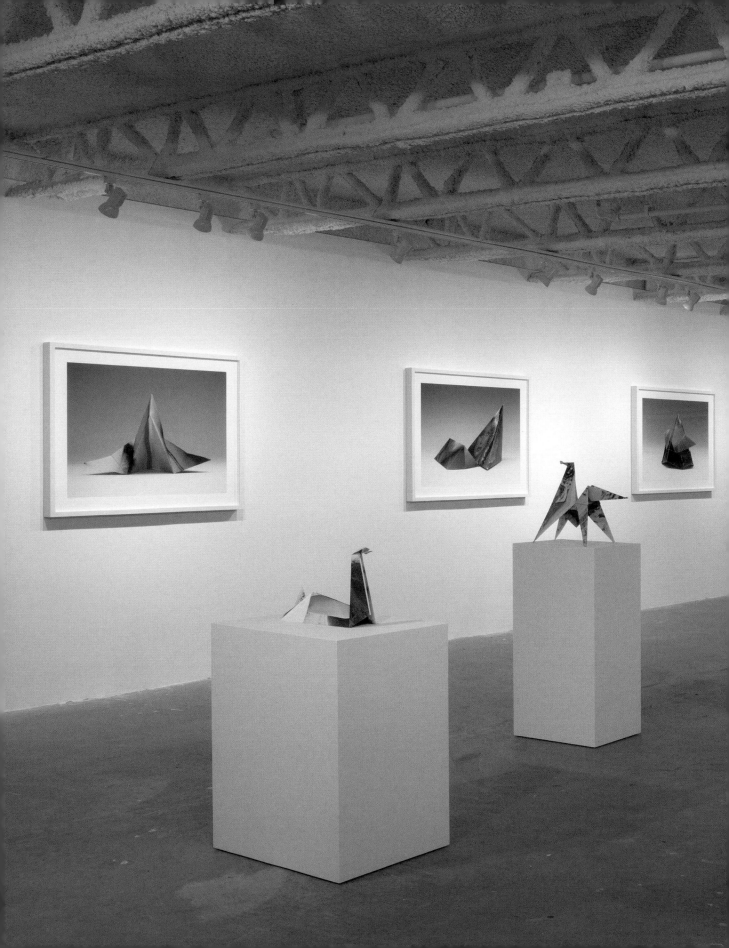

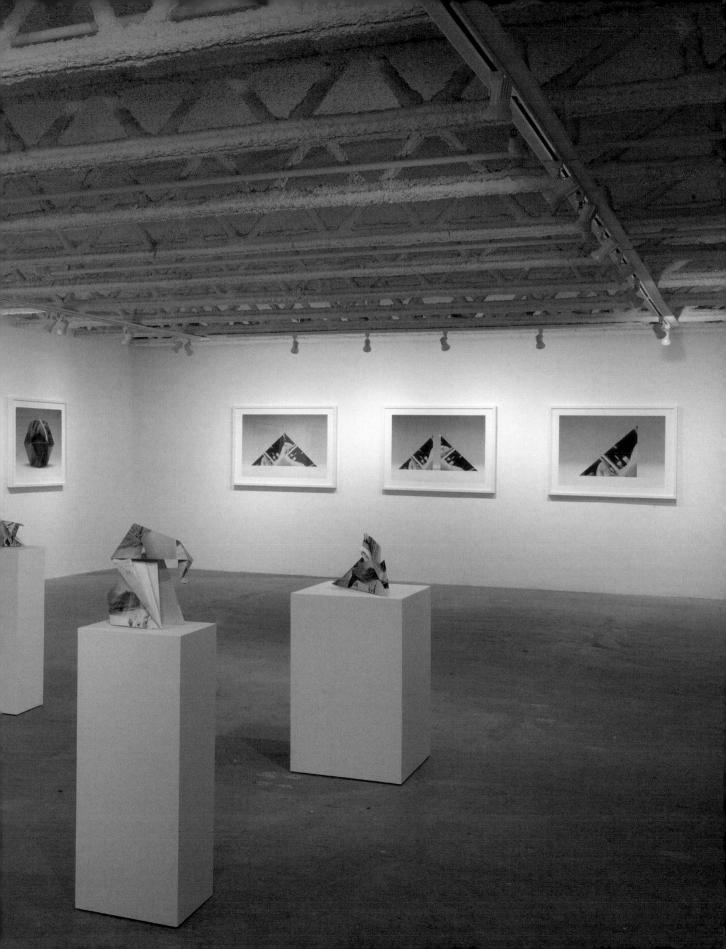

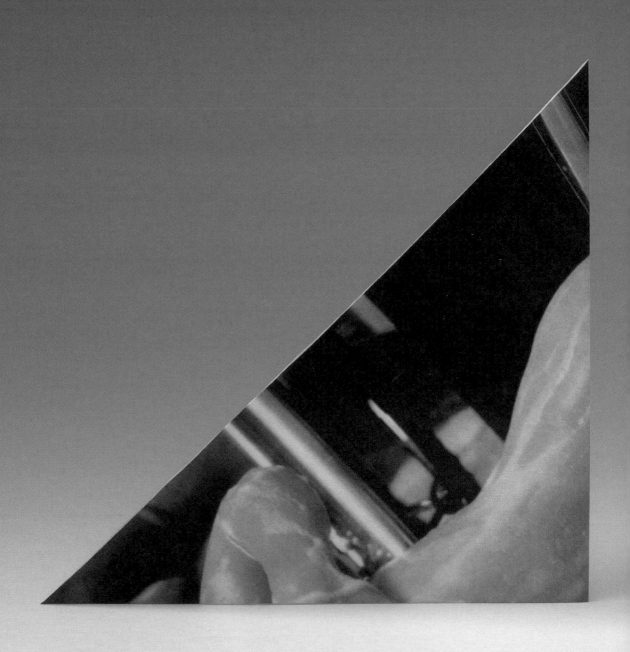

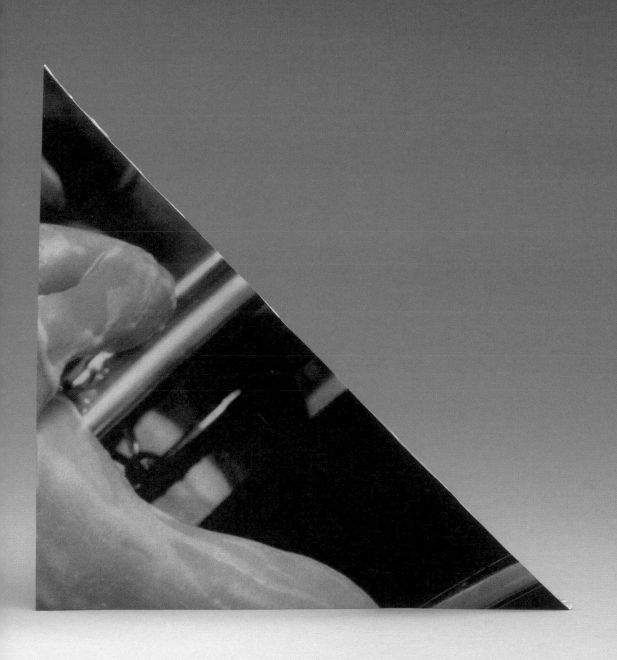

PP. 60–61
Installation view of MacLeod's exhibition
Dorothy at Presentation House Gallery
Satellite, 2012

PP. 62–63
Splitting, 2012
inkjet print
76 x 101.5 cm
Courtesy Catriona Jeffries Gallery

Windfarm, 2012
inkjet print
76 x 101.5 cm
Collection of Dominique Toutant

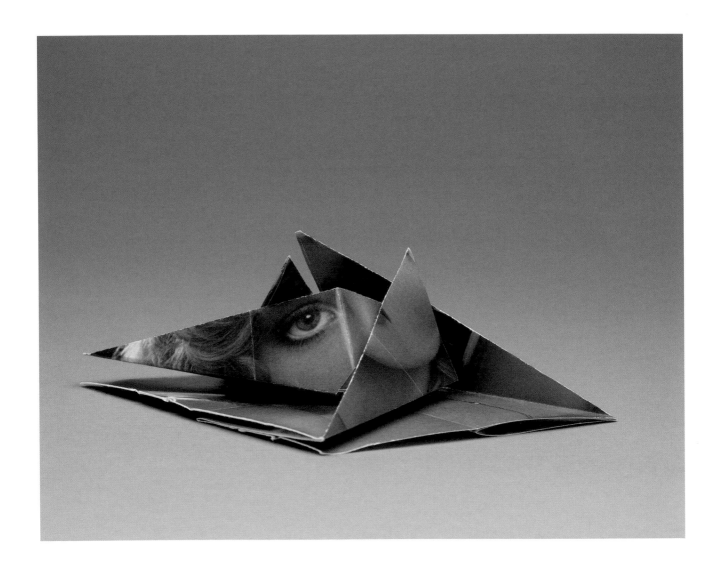

Shipwreck, 2012
inkjet print
76 x 101.5 cm
Courtesy Catriona Jeffries Gallery

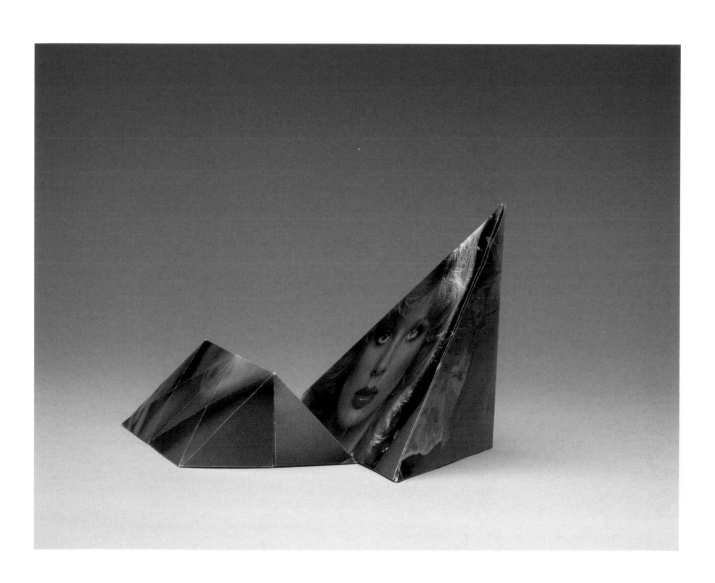

Artifact, 2012
inkjet print
76 x 101.5 cm
Collection of François Roy

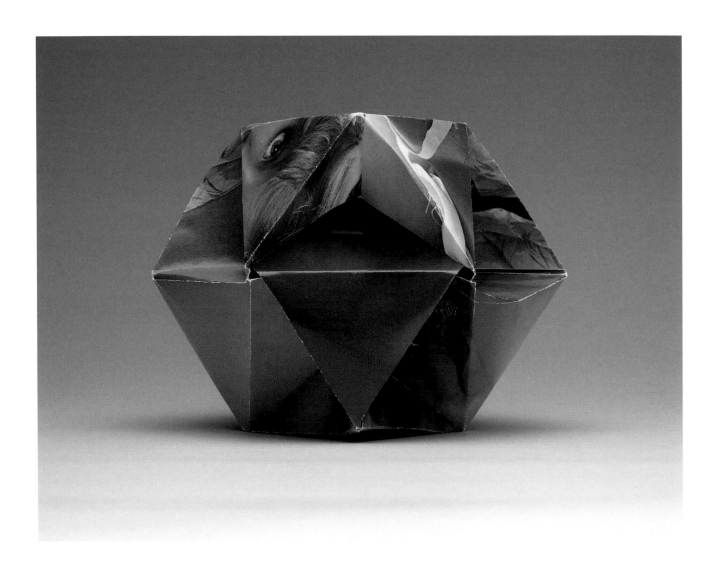

Kabuto, 2012
inkjet print
76 x 101.5 cm
Courtesy Catriona Jeffries Gallery

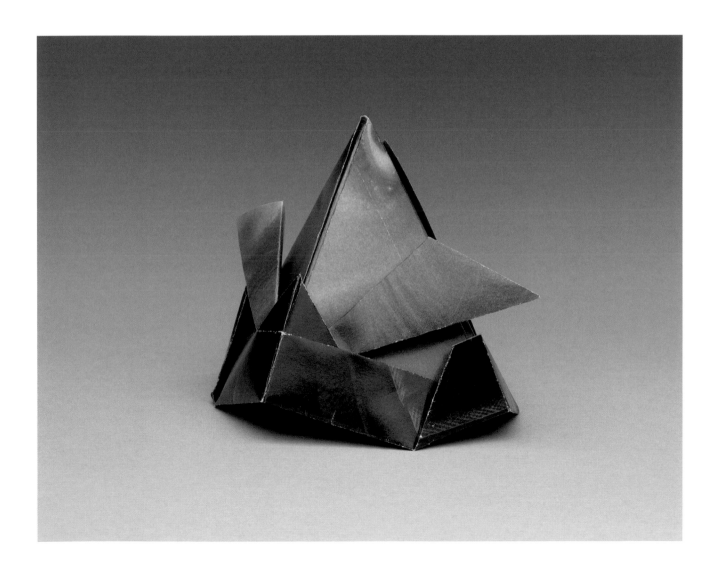

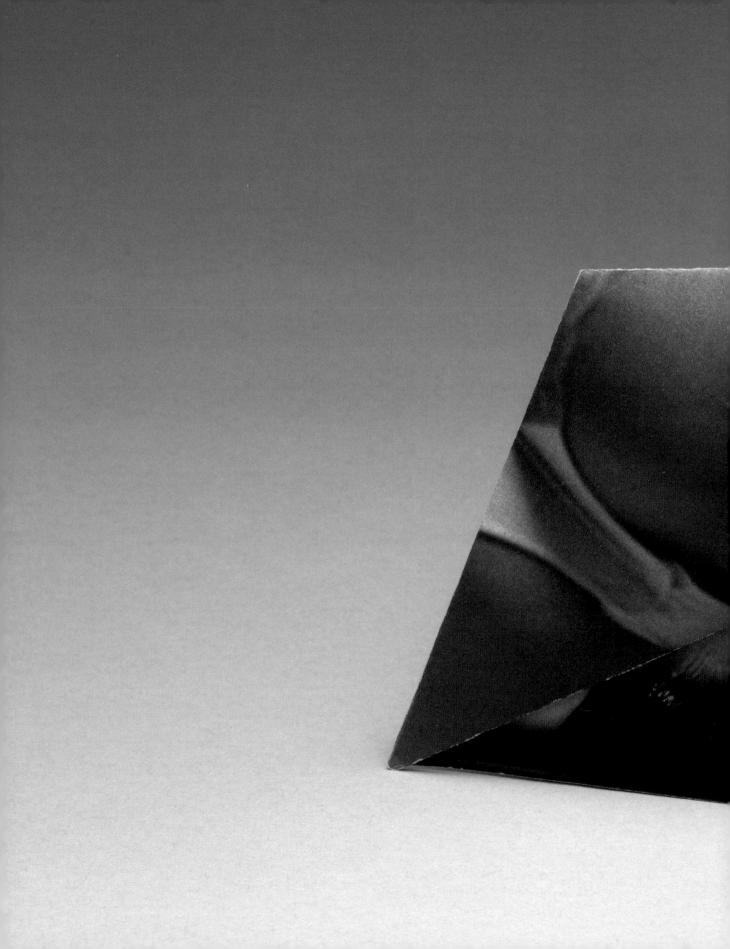

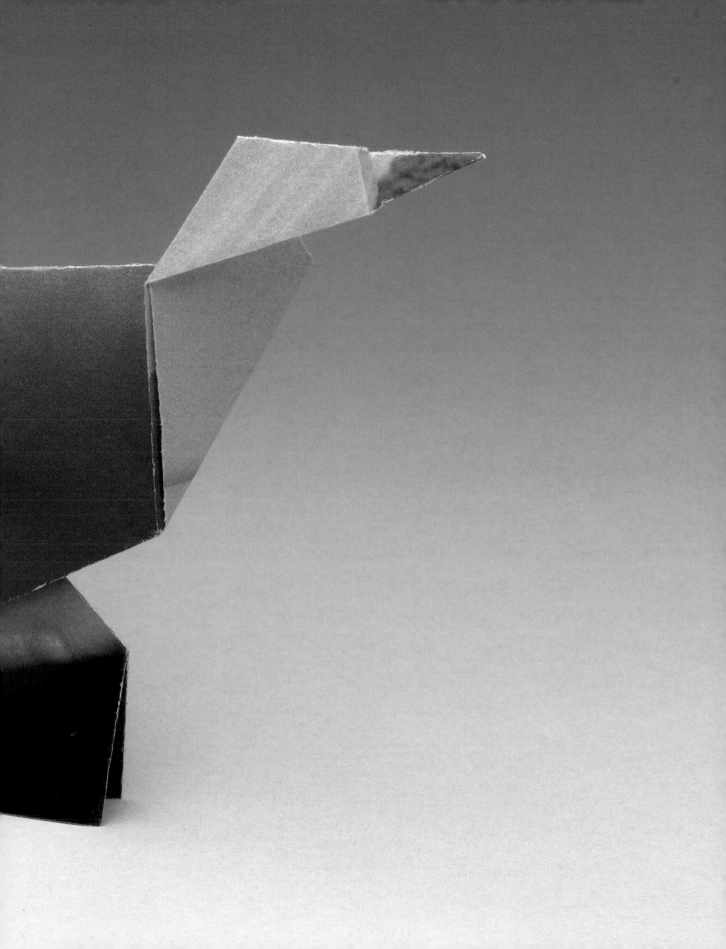

PP. 68–69
Cormorant on a Rock, 2012
inkjet print
76 x 101.5 cm
Courtesy Catriona Jeffries Gallery

Tsuru, 2012
inkjet print
76 x 101.5 cm
Courtesy Catriona Jeffries Gallery

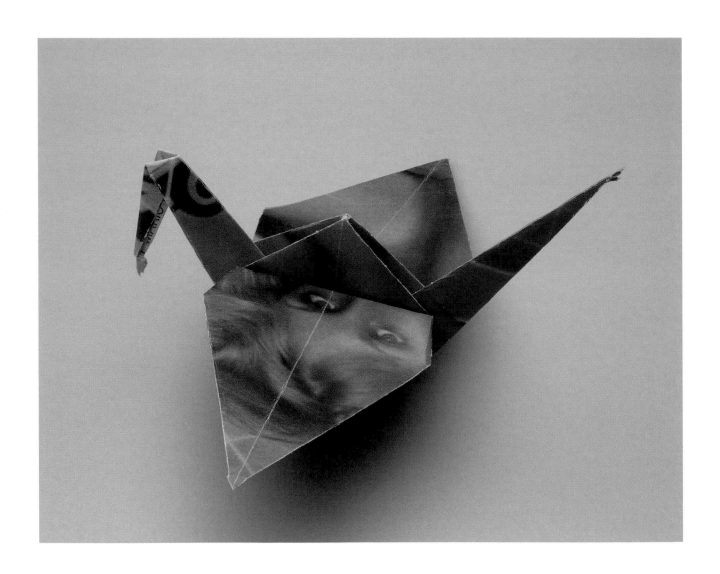

Piranha, 2012
inkjet print
76 x 101.5 cm
Courtesy Catriona Jeffries Gallery

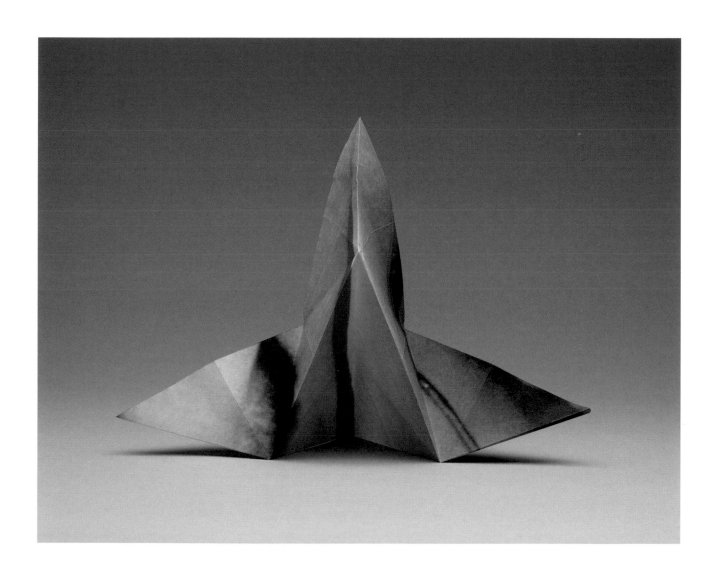

TOO OLD FOR THE DRAFT

My necking days are over
My parking lights are out
And what used to be my sex appeal
is now my water spout.

I used to be embarrassed
To make the thing behave
For every single morning
It stood and watched me shave.

But now I'm growing older
And it sure gives me the blues
To have it dangling down my leg
And watch me shine my shoes.

Happy days have come and gone
The fire of youth is out
What was once a magic wand
Is only a water spout.

OPPOSITE
Too Old for the Draft, 2014
found photocopy of an unidentified
poem
27.8 x 21.6 cm
Collection of the Artist

*I've been without hair for so long I forgot
what I looked like*, 2014
found photocopy of an unidentified
cartoon
11.8 x 7.8 cm
Collection of the Artist

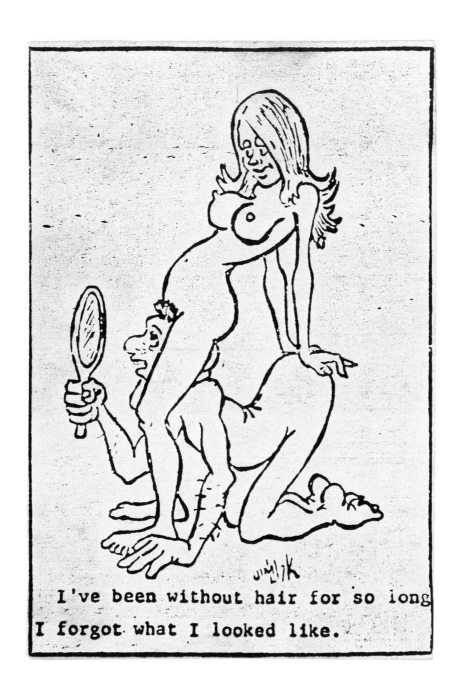

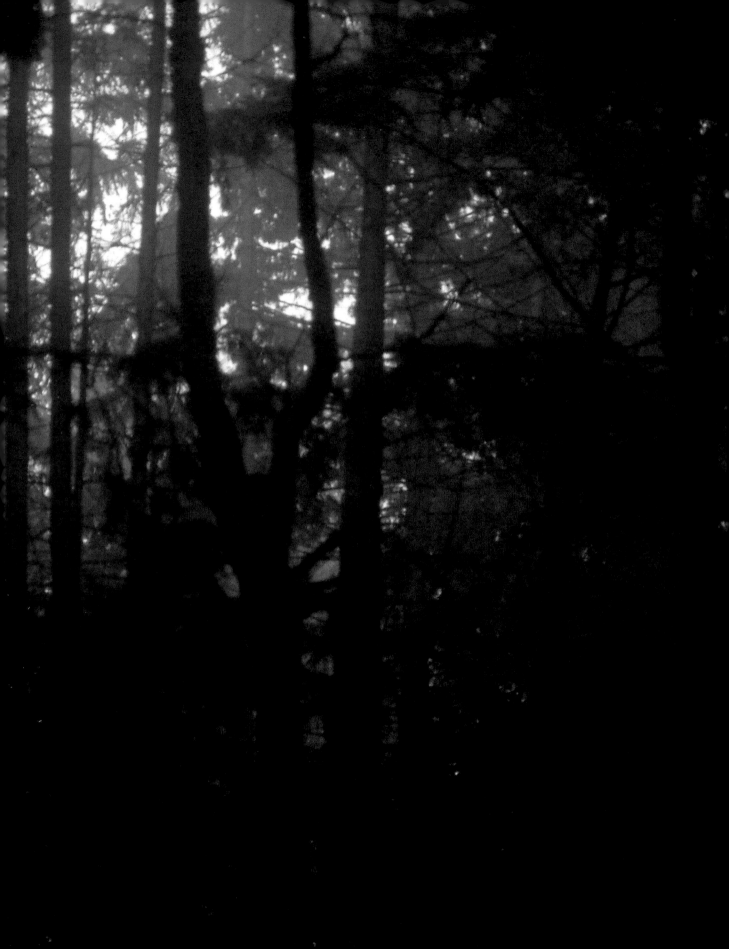

The Music Appreciation Society

In many ways, listening to music is easy. Here are several common scenarios: you take a large, typically black disc out of its paper covers and put it on a turntable. Next, you put the needle arm down with a click and a thump and wait a tiny bit for it to play, shrouded in quiet crackle. Or maybe you open a clear, flat plastic box and take out a smaller shiny disc, which gets put into a plastic chamber. Inside it gives a faint whir, as you wait for it to engage and play, this time shrouded only in silence. Or maybe you just tap away at a keyboard or move a blinking cursor to make it play with a touch or a click, summoned from an endless sea of data. Or maybe you—and increasingly most of us—do a version of something like the latter, but on a phone or some other device while on the go. Whichever behaviour is required, the result will be a playback that transforms sound that was variously encoded as audio back into sound, a form of transubstantiation halfway between science and magic.

After those steps, sound vibrates materially through speakers and into a room or a car, or through headphones directly into ears and thus the head. Indeed the ears, but especially the head (the contents of which we'll leave aside for now), are involved no matter which playback situation is used. Mostly, of course, it's not just any old sound invoked in this way, it's *music*, even if other types of sounds could potentially be called up through the same processes as well. Despite the intervention of John Cage, who strove to embrace all kinds of unmusical sounds in his work, music simply isn't just a kind of unvarnished sound, even if it sometimes makes use of sounds that would be hard for many to classify as conventionally musical. What's important here, as the

philosopher Roger Scruton notes, is to appreciate that, "to hear a sound as music is not merely to hear it, but also to order it."[1]

Somewhat circularly, the kind of ordering Scruton means relates to Western musical practice, which he argues is guided by reason and based on the compelling power of tone, by which he means musical sounds. To be sure, his view is traditionalist and the idea of order he suggests seems at first to be too limited, even restrictive, especially considering today's sometimes wide-open musical preferences and hybrid forms. Yet the basic argument helps makes an important point: listening to music only seems straightforward. Scruton is right to say that when we listen to music we are simultaneously listening to something other than sounds in a direct way, as if simply hearing the proverbial tree falling in the woods. To help elucidate this evaluation, while teasing out the multilayered distinction between listening and hearing and the roles of the mind (the seat of the self) and the body, let's take the optimal example of listening to music as a case study: the music of Led Zeppelin.

Arguably *the* classic rock band, Led Zeppelin are so famous and much of their music so well known that it's hardly necessary to introduce them again here, and this already helps make our case. Significantly, that background awareness, which is based as much on myths and half-truths as real biography, is an aspect of the experience of their music. In other words, one never just listens to Led Zeppelin but for the whole *aura* of Led Zeppelin. And not just their aura: the entire ensemble of practices, experiences and knowledge accumulated around them is part of the experience of

P. 74
Don't Stop Dreaming, 2004 (detail)
speakers, CD, carpet, wallpaper mural
dimensions variable
Courtesy Catriona Jeffries Gallery

their music, including, but not limited to, what the critics have said and what the fans have done. But this is not to dismiss the singularity of their music. Their combination of rock, blues, folk and funk made a new template, backed up by peerless musicianship and, on record, innovative recording and production strategies. Even without the extra-musical hype and apocrypha, Led Zeppelin would undoubtedly have earned their place in the popular canon, despite their early (and now surprising) lack of critical respect, as described by Stephen Davis in *Hammer of the Gods: The Led Zeppelin Saga*.[2]

Whether by plan or intuition, Led Zeppelin seemed to understand that they were as much a musical act as a focal point for the imagination. Much can be made of the drugs and alcohol, the sex, the overwhelming sound and noise, and the dark influence of the magick of Aleister Crowley, but the most transforming thing about Led Zeppelin is the space they opened up around themselves, a space that has yet to close. But even if it is more than Led Zeppelin's music alone that sustains this space, it would be incorrect to undervalue the actual sound of the band's music in establishing it. As Susan Fast points out, Led Zeppelin's "experimentation with sound, especially [Jimmy] Page's trademark use of the violin bow to play his electric guitar, radically expanded the sonic palette, serving as a metaphor for the expansion of consciousness into unchartered territory."[3]

At their most musically transgressive, Fast remarks, Led Zeppelin are profoundly psychedelic, "the musical equivalent of hallucinogenic experience," particularly during Page's extended improvisations.[4] Noting that "psychedelic music was generally termed or identified as 'head music' (and its

proponents 'heads')," Benjamin Halligan draws a useful parallel with conceptual art: "the materiality of the artifact becomes irrelevant, and any questions of 'correctness' or technique prompted by the artifact rendered irrelevant too, once it is understood that the artifact intends to speak directly to 'the head.'"[5] In the context of the overwhelming volume of a Led Zeppelin live show, this "speaking to the head" manifested in an extreme way, inspiring a radical disconnection or mind-body dualism. As recounted by Erik Davis (and indeed confirmed by John Paul Jones in an interview in the *NME* in 1973), legend has it that the audience at a show in 1969 at the Boston Tea Party was actually banging their heads against the stage, the birth of the expression "head bangers."[6]

Understandable as that audience's response might be, no amount of banging will dislodge the psychedelic space inside the head. If anything, the space or void inside the head is unavoidable, even foundational, albeit paradoxically. In fact, the space that Led Zeppelin opens echoes (and echoes within) the central mystery in us all: the space of the self. This is no mere affinity. Mystery is something else Led Zeppelin does well. Released in 1971, the fourth Led Zeppelin album for Atlantic Records, still untitled, remains one of the most cryptic documents in popular music, irrespective of (but partly the basis of) its renown. Not only does the album lack a proper name to identify it, it also offers no text of any kind on its front and back covers, spine or inside cover. The inside sleeve provides song titles, some basic production information and the cypher-like lyrics to "Stairway to Heaven," as well as the famous occultish sigils chosen by the band to represent their names. A mundane

explanation for this graphic choice is an aggravated retribution by the band, granted unprecedented creative control over their albums' sound and look, to a popular music press they perceived to be lame.

This kind of purposeful withholding of information, and consequently of self-presence, has historical antecedents that speak to the issues of sound, listening (especially as it relates to but contrasts with hearing), the body and mind, and the notion of the self. For example, legend has it that the aspiring followers of the philosopher and mystic Pythagoras (ca. 570–495 BCE) were made to silently listen to him speak from behind a curtain for a period of years, as part of the process of initiation into his teachings.[7] By carefully listening like this, the *akousmatikoi,* or "listeners" as they were known, supposedly encountered his philosophy more directly, specifically without visual distraction. Emphasizing the character of the speaking voice, this mode of presentation also undoubtedly fostered a sense of drama and power beyond the specific content of Pythagoras' instruction.

In recognition of the influence of technological mediation such as radio, this principle was reinvented and taken up in the 1940s by Pierre Schaeffer, the composer and writer who helped found and develop *musique concrète,* an early electroacoustic compositional practice that used manipulated recorded sounds. Schaeffer's idea of "acousmatic sound," as he called it, aimed at a similar kind of focused sense experience, albeit missing the cultivated aura of mystery invoked by Pythagoras.[8] Schaeffer called this listening strategy "reduced listening," a term indebted to the philosophical strategy of phenomenological reduction, derived from Edmund Husserl, which involves a kind of intellectual disconnection

or suspension: a "bracketing" of judgment about what one already knows about things and the world, etc., from what one is immediately experiencing.

It's worth putting Led Zeppelin aside for a moment to fully follow the implications of this, which will ultimately help us get back to where we started. When it comes to our everyday experience of sounds, especially nonmusical ones, it's remarkably easy to fail to really listen to sounds themselves and instead rush quickly toward identifying the apparent sources of what we hear. As Christian Metz points out, this kind of identificatory leap fails to appreciate sounds as specific "aural objects," categorizing them instead as subsidiary attributes of the sound-making objects that produced them, effectively bypassing sounds in all of their material particularity.[9] Ironically, one result of this kind of habitual shortcut is an inverted kind of bracketing; what gets withheld is precisely an activated engagement with sounds in lived experience.

Does engagement with sound simply require more careful, attentive listening? Not necessarily. Albeit closely tied to functional self-awareness, both in terms of the self and of the world, listening is often taken as the privileged capacity with respect to the sensation of sound. But our relationship with sound is only partly based on the seemingly self-evidentiary perceptual activity of listening. The relationship actually starts in the body of the receiver with hearing, and this distinction is worth elaborating. Certainly, hearing is on a continuum with listening within the overall process of appreciating sound. However, it is more of a kind of animalistic sensory reflex than listening, which is a purposeful activity, directed by intention and effort. As a

Drum kit from the Scottish band
Filthpact, photograph by Myfanwy
MacLeod, 2005

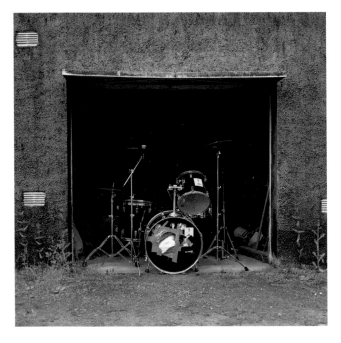

generalized, constant receptivity—a capacity of the body even before the conscious appreciation of the self—hearing happens even if we stop paying attention, including during sleep. Always and already ongoing, hearing seems to filter through the preconscious (probably also unconscious) part of us, and then feeds into the full consciousness of listening. And even as the once heard seems to slip away, replaced by the categorizations and deliberations of listening, hearing continues to haunt listening as a background, the elusive source of its first input.

To privilege hearing over listening suggests a privileging of the body over the mind and the sense of the self. It's easy to recall here Led Zeppelin's audience in Boston, so overcome by high volume sound as to bang their heads on the stage—as if their bodies themselves, reflexively on their own, couldn't help it. The implication is that the body is able to receive a more direct, thus more authentic impression of sound in the world through hearing than we are ever able to appreciate with our conscious acts of listening, which also puts music into a curious kind of suspension. Listening is forever tied to the drive to categorize, and therefore doomed to the potential impurity of our processes of understanding. Consequently, listening becomes a kind of supplemental response to the world, albeit closely related to it: its basis is still ultimately the raw material of hearing, which is gathered without judgments of value and style.

A possible outcome of a hearing-based relationship with sound over a listening-based one is a potential dissolving of the subjective sense of self into the unmitigated carnality of the body, head banging included. In his essay "The Grain of the Voice," Roland Barthes describes a relationship of this type. He begins by first noting that discussions of music are too often confined to the "poorest of linguistic categories: the adjective."[10] These adjectives foster predicates, which ultimately become "facile and trivial" epithets.[11] More than poor writing, this slippery reduction serves to reinforce the constitution of the subject, which is not only the target of a predicate, grammatically speaking, but also the central conceptual figure for the whole ethos of Western thought. Rather than trying to correct language, however, Barthes seeks to challenge the way music, specifically here vocal music, is presented to "perception or intellection."[12] Toward that goal, Barthes identifies "grain" as the "body in the voice as it sings."[13]

Detail of drum kit from the Scottish
band Filthpact, photograph by Myfanwy
MacLeod, 2005

Barthes is careful to distinguish what he means by "grain" from what is conventionally known as "timbre," which is the so-called colour or harmonic quality of a voice, or indeed any sound. While timbre is in part determined by the materiality of a sounding body, human or otherwise, it is also a quality that can be altered through practice and technique. Highly sensitive and versatile, the human voice in particular is able to achieve a great range of timbral qualities, perhaps more than any other instrument. Not coincidentally, timbral variability is most often also described adjectivally: this voice is rough, that one is smooth. A synthesizer as much as a chameleon, Robert Plant's voice is oftentimes both.

As Barthes is quick to point out, however, timbral effects have more to do with expressiveness, which he aligns with the normal practice of well-trained singing and "acknowledged tastes," than with the notion of grain he's proposing.[14] The phenomenon Barthes enjoys is, instead, a form of friction or play between music and lyrical texts. In particular, it is the body, one shorn of subjectivity and "civil identity," which is a key vehicle of grain.[15] With singing in particular, Barthes cites the throat, tongue, glottis, teeth, mucous membranes and nose as different bodily points of "gesture-support."[16] Certainly, Plant's body (and his long and golden hair) is an important aspect of his performances, and it's clearly evident in his voice, most particularly when he engages in scat-like interplay with Page's guitar, replacing lyrics with moaning, groaning and other nonverbal sounds. Thinking of such vocalizations, Fast, for one, endows Plant with grain: he holds his "emotional core… out to the listener through his voice."[17]

Although Barthes locates grain in a singer's voice, he also acknowledges his own position as a listener, which he describes as being "individual" but not "subjective."[18] More than terminological, this important distinction parallels the one Barthes makes between grain and expression: the latter takes place within the coordinates of established cultural values, the former in terms of an erotic relation between bodies—the "impossible thrill" of *jouissance*.[19] An intense feeling of bliss, profound enough to displace the subjective sense of self with a trippy sense of loss, jouissance is a key concept for Barthes, forming part of a "dialectics of desire," as he describes in his essay "The Pleasure of the Text."[20]

Remarkably, the antipode of jouissance for Barthes is not an equally overwhelming sense of badness, but pleasure. He argues that texts (extrapolating here to include the musical texts he writes about in "The Grain of the Voice") that give pleasure—that fill the reader with contentment and even

euphoria—are "linked to a *comfortable* practice of reading."[21] In other words, pleasure seems to be granted by and take place within an existing context of values and meaning. Rubbing untowardly against this context, a text that gives jouissance therefore provides a kind of displeasure: it deeply "unsettles" the reader by challenging their "historical, cultural, psychological assumptions," all the way down to their foundation in language itself.[22] As with the distinction between hearing and listening, the body, linked with jouissance, is assumed in contrast to the context that provides pleasure, which is the purview of cultured tastes and intellection.

If we put music back into consideration here, following Scruton's point about order, it seems more to occupy the cerebral position of pleasure, in contrast to the jouissance of the body. Alternatingly giving pleasure and jouissance, how then to best describe one's response to the music of Led Zeppelin? Thankfully, while comparing texts that grant pleasure with those that grant jouissance, Barthes offers one possible answer:

> Now the subject who keeps the two texts in his field and in his hands the reins of pleasure and bliss is an anachronic subject, for he simultaneously and contradictorily participates in the profound hedonism of all culture (which permeates him quietly under cover of an *art de vivre* shared by the old books) and in the destruction of that culture: he enjoys the consistency of his selfhood (that is his pleasure) and seeks its loss (that is his bliss). He is a subject split twice over, doubly perverse.[23]

If Barthes didn't have Led Zeppelin (and many of their fans) in mind when he wrote those words, he might as well have. They seem almost taken straight from a promotional package about the band or maybe the lost liner notes for their nameless fourth album—some woolly buzz to excite the crowds and confound the critics. In any case, the subject Barthes identifies here—a subject that is anachronic and thus always out-of-step, but also enjoys a kind of chthonic indulgence all the same—is granted a final yet key measure of agency: the reins are in their hands. Despite his claim that "the pleasure of the text is that moment when my body pursues its own ideas—for my body does not have the same ideas I do," Barthes actually describes less of a truly sundered subject than a game epicurean one, flipping between modes of enjoyment, cruising bliss if never really surrendering to it, listening appreciatively to the ideas of the body if not fully hearing them.[24]

While this kind of Barthesian connoisseurship in fact rings true with much of the experience of listening enjoyment, which moves back and forth between pleasure and jouissance, what then of the empty space of the head? To help us lose ourselves there again, Jean-Luc Nancy offers a nuanced model of the subject in his book *Listening*, which holds a relationship with sound to be paradoxically fundamental:

> The subject of the listening or the subject who is listening (but also the one who is "subject to listening" in the sense that one can be "subject to" unease, an ailment or a crisis) is not a phenomenological subject. This means that he is not a philosophical subject,

and, finally, he is perhaps no subject at all, except as the place of resonance, of its infinite tension and rebound, the amplitude of sonorous deployment and the slightness of its simultaneous redeployment—by which a voice is modulated in which the singular cry, a call, or a song vibrates by retreating from it (a "voice": we have to understand what sounds from a human throat without being language, which emerges from an animal gullet or from any kind instrument, even from the wind in the branches: the rustling toward which we strain or lend an ear).[25]

Like Barthes, Nancy's larger argument relies on wordplay in French that doesn't transfer easily to English. He also flips the distinction usually given between listening and hearing, locating listening at the "bottom" of hearing, rather than vice versa.[26] He justifies this orientation by pointing out that "to hear" in French, *entendre,* also means "to understand," *comprendre,* a conflation shared colloquially in English. Recalling both Scruton and Metz, Nancy's position is that hearing is therefore always a "hearing say," even if what's heard is not a word but some other kind of sound.[27] As he elaborates: "If 'to hear' is to understand the sense (either in the so-called figurative sense, or in the so-called proper sense: to hear a siren, a bird, or a drum is already each time to understand at least the rough outline of a situation, a context if not a text), to listen is to be straining toward a possible meaning, and consequently one that is not immediately accessible."[28]

With his emphasis on listening, for him something ultimately more cognitive—an active searching for meaning—than reflexive, it's not surprising that the body is mostly implicit (if not missing) in Nancy's analysis of the subject as a space of resonance. Defined by the "presence of presence rather than pure presence,"[29] the curious *space of the subject that is a space* that Nancy describes is empty but for the redoubled coming and going of sound and meaning, which he says both constitutively "share the space of a referral."[30] This means that the space of the subject is also the passage through that selfsame space: an echo chamber in which the echo is itself the natural expression of the subject rather than the audible reflection of some other subject who acts. Even more, any form of self-presence the subject might have is always already a mixed-up recognition of itself sensing while also sensing itself sensing, initiating a pattern that, in true psychedelic fashion, could repeat forever.

With all due respect to Nancy's model of the self, it's easy to get the impression that he's unintentionally also offering a version of a classic put down: "airhead." This association isn't meant to be silly or cheap. Nancy offers a highly elusive model that throws the subject, conventionally understood, far into question. For if the brain is the material seat of the mind and the mind the organic apparatus for the sense of subjective consciousness that gives structure to the self, Nancy's model seems to purposefully let a lot go "in one ear and out the other," as the old saying goes. In this case, the airhead he identifies isn't some species of "dummy" or "stoner"—two insults historically thrown at rock music enthusiasts, including Led Zeppelin fans—but the true character of the self. Empty as it might seem, however, it's important to remember that Nancy's airhead also listens, which recalls the music that "speaks to the head" that Halligan identifies. And why not? What better way to traverse our airheads than with music?

Stack, 2013
18 screenprints on canvas, metal
hardware, vinyl
121 x 121 x 12 cm each
Courtesy Catriona Jeffries Gallery

88

The Emptiness, 2013 (detail)
heavy metal logo cut in metallic vinyl
dimensions variable
Courtesy Catriona Jeffries Gallery

PP. 90–91
Don't Stop Dreaming, 2004
speakers, CD, carpet, wallpaper mural
dimensions variable
Courtesy Catriona Jeffries Gallery

PP. 92–93
Still from *This is Spinal Tap*, 1984, with
"volume 11" amplifier

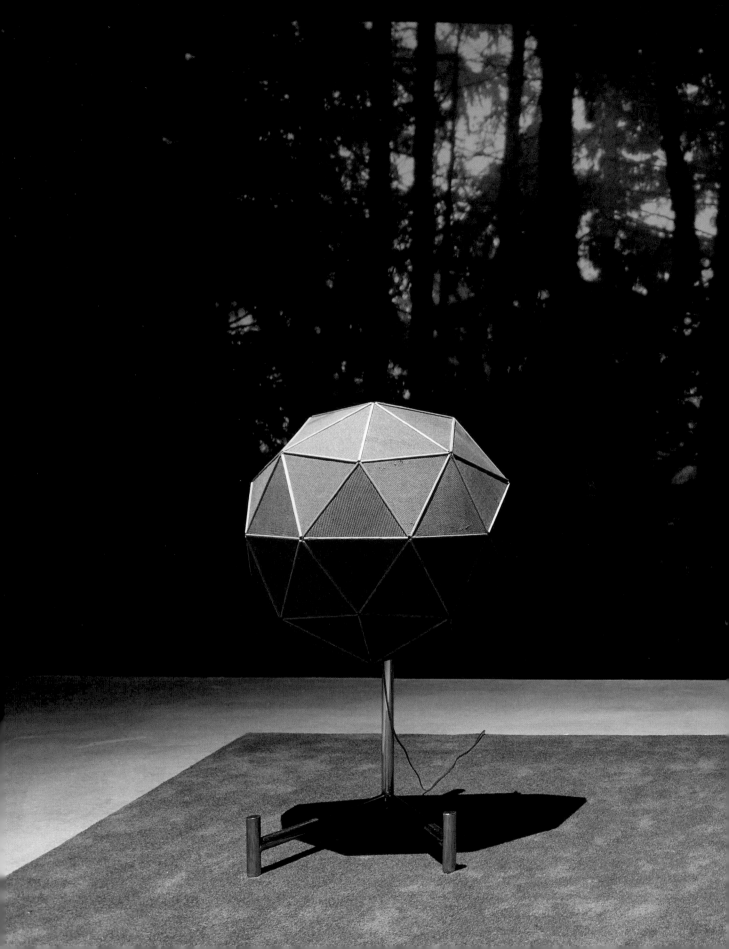

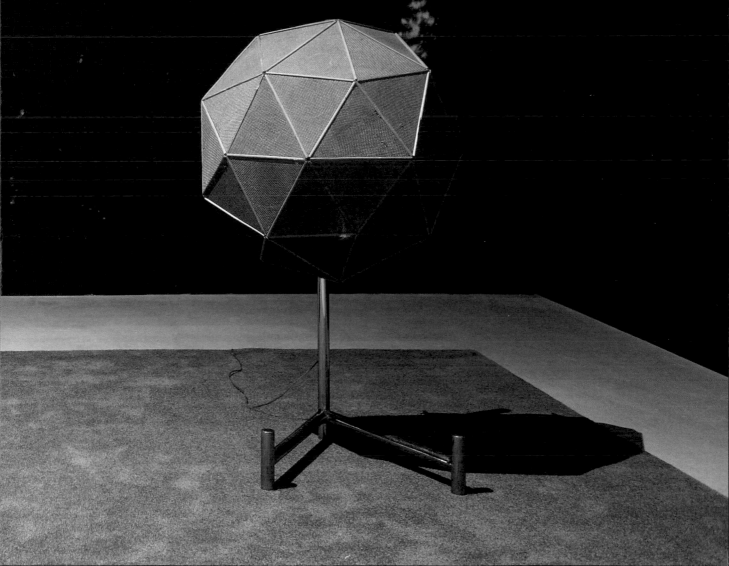

SPECIFIC OBJECTS, PROFANE ILLUMINATION

Grant Arnold

I first heard Led Zeppelin's music in the spring of 1970. I was fourteen, hanging out and listening to records in the semi-finished basement of a friend's house in a middle-class neighbourhood in Saskatoon. Shaped largely by the programming of the local am radio station, my knowledge of rock was limited. The station only played singles, mostly Top 40 material, and therefore no Led Zeppelin at that point in time. Its playlist had included songs like Cream's "Sunshine of Your Love" and Jimi Hendrix's version of "All Along the Watchtower," so I had some exposure to hard rock and virtuoso guitar playing. Nonetheless, when my friend's older brother put Zeppelin's second album on the turntable and "Whole Lotta Love" came pounding out of the speakers, the stripped down structure of the song, Jimmy Page's searing guitar licks and Robert Plant's orgasmic howls possessed an aural intensity we'd never encountered before. Like all adolescent boys, we delighted in the allusions to sex that ran through most pop music, even if they were smoothed over in a fashion that made them acceptable for play on mainstream commercial radio in a small, culturally conservative prairie city. However, there were no codes to mask the intent of "Whole Lotta Love," never mind kisses: this song was clearly about fucking, something with which we were, of course, obsessed but hadn't experienced. More than any other music available to us at the time, "Whole Lotta Love" seemed to bring the possibility of getting laid a bit closer and Led Zeppelin quickly became one of our favourite bands.

A couple of years later I began to play bass in a "basement band."[1] While Led Zeppelin was held in high esteem by all of the band members, we didn't play any of their songs.

With a lot of prompting our guitar player was willing to take a stab at emulating Page's spectacular guitar solos, but there was no way we could get the singer to try to mimic Plant's wailing vocals. He knew that, with his squeaky adolescent voice, such an effort could only end in ridicule, so we stuck to covers of songs by bands like the Rolling Stones, James Gang and Deep Purple. This was material in which attention would be focused more on the band as a whole, so any scorn directed toward our less-than-accomplished musicianship would be borne collectively and none of us would seem to be any worse than the others.

Although our amplifiers were loud enough to make our playing heard throughout whichever house we happened to be practising in, our equipment always seemed a bit puny. By the early 1970s Led Zeppelin, as well as The Who, Cream and Hendrix, had made it clear that volume was crucial to rock; it was about power and it was meant to be felt as much as heard. So what we really wanted was a Marshall stack, a massive wall of Marshall amplifiers and speaker cabinets, to form the backdrop at our (few) gigs at elementary school dances. If it was obvious we couldn't plausibly cover any Zeppelin songs, we fantasized that the sonic force of a Marshall stack would give our performances a little bit of the visceral power found in Zeppelin's music.

¶

Marked by a sometimes caustic sense of humour, the work of Myfanwy MacLeod draws upon an eclectic set of references—from conceptual art and Minimalism to motifs salvaged from music, cinema and popular literature. Hinging

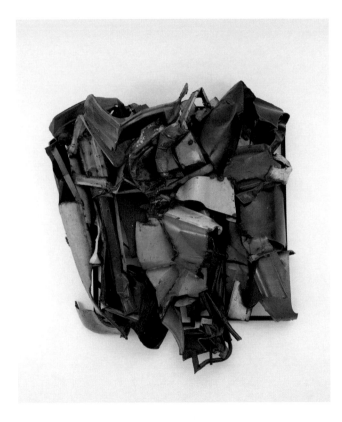

on linguistic slippages and unexpected flashes of recognition, it uncovers new meanings and points of intersection within iconic episodes in mass culture and the history of modern art. MacLeod's is a largely post-studio practice that often follows a model initially affiliated with 1960s Minimalism and the work of artists such as Donald Judd and Tony Smith. Using a variety of media, she skirts the inflection of individual expression by having much of her work fabricated

by others. Nonetheless, the materials and processes used in its production and their intersection with traditional forms of art making are important in situating her work in relation to both past traditions and its contemporary context. MacLeod's *Stack*, for example, is comprised of eighteen units, each of which are slightly larger-than-life imitations of the front four inches of a Marshall speaker cabinet; the type used in a Marshall stack, an amplification system that has become an iconic symbol of sonic power in large-scale rock concerts. The central element of each component is a canvas that has been painted a monochromatic black. The white Marshall logos were screen-printed on to the black background at an artist-run centre that focuses on printmaking, while the vinyl-covered "frames" that surround each canvas were constructed by a firm that specializes in producing frames for more conventional artworks.

The eighteen units of *Stack* are installed, ideally, on a wall in a grid of three by six units. This modular structure and the title of the work recall Judd's "stacks," an extended body of work comprised of vertical arrangements of rectilinear units he began in 1965, the same year the Marshall stack first appeared on a concert stage. As a set of framed canvases that protrude out from the wall into the physical space of the gallery, *Stack* embodies characteristics of both painting and sculpture while extending beyond the domain of both categories. This aspect of *Stack* is a deliberate reference to the critique of modernist painting and sculpture articulated in Judd's essay "Specific Objects," a seminal text in the development of Minimalism that was originally published in *Arts Yearbook 8* in 1965.

In "Specific Objects" Judd articulated an approach to art making that broke with traditional forms of presentation

associated with painting and sculpture, in an effort to engage the viewer on new terms that were unbound by the anthropomorphism and pictorial structures embedded in European modernism—a field that, in Judd's view, had become "a rather stagnant pond."[2] Judd coined the term "specific object" to describe a new, specifically American tendency that could be seen in work by artists such as John Chamberlain, Claes Oldenburg and himself (among others). He referred to this work as "objects" to evade categorical identification as either painting or sculpture, terms that Judd saw as "set forms" or "containers of meaning" that predetermined the viewer's response to an artwork. These objects were "specific," as the artists' careful orchestration of shape, scale, proportion and materials produced work that was "more intense, clear and powerful" than work aligned with traditional versions of modernism. Most of the artworks Judd described were three-dimensional; they either projected off the wall, countering the conventional relationship between painting and the wall as support, or sat directly on the floor, dispensing with sculpture's traditional plinth. Engagement with "real space"—the space occupied simultaneously by the work and the viewer—was crucial for the specific object, which in its denial of illusionism and literal space attempted to shift the viewer's attention away from predetermined perception and toward the immediate reality of his or her encounter with the art object at a particular time and place.

Judd's identification of the specific object was seen as a radical break from the conventional role of the artist as a producer of meaning and from established modes of composition that were grounded in aesthetic judgement.

Judd favoured the use of common industrial materials such as Formica, aluminum and cold-rolled steel in works that could be constructed by fabricators rather than the artist. In opposition to a process in which the artwork is composed "part by part," Judd argued for non-relational configuration based on some kind of existing system, such as repetition or counting, that could produce a structure in which "order is not rationalistic and underlying but is simply order," and in which hierarchies are absent and order is supplanted by a sense of continuity, of "one thing after another."[3]

MacLeod's *Stack* is both an homage to the specific object and a deliberate travesty of the terms by which Judd defined it. The hybrid character and ordering logic of *Stack* correspond to the characteristics of the work Judd advocated in "Specific Objects," but MacLeod's use of vinyl, hardware and pre-painted canvas to emulate the appearance of a Marshall stack challenges Judd's characterization of industrial materials as "obdurate" and rejects his claim that such materials can be free of metaphoric association. Unlike the precise equilibrium of Judd's stacks, in which the space between each element is equivalent in size to the element itself, the spaces between the components of *Stack* are considerably smaller and the sense of *gestalt* that played such a central role in Minimalism is discarded as a no-longer-viable aesthetic principle. While each of the cantilevered elements of Judd's stacks appear to be distinct, self-sufficient entities within the overall structure, MacLeod's embrace of mimesis implies both a relationship to something beyond the exhibition space and the implication that each of *Stack*'s components is an incomplete fragment of the thing it mimics. They appear to either be in the process of being

Cover of *1977 Camaro Owner's Manual*

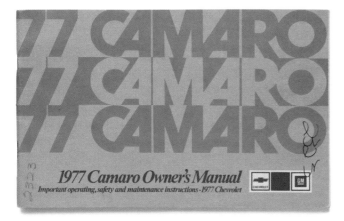

conception of the carnivalesque, with its suspension of normative order in the "exuberance of ceaseless excess."[5]

While physicality is also central to the experience of Judd's work, it doesn't have much to do with ceaseless excess, and whatever loss of control one might find there is far more subtle than what one might encounter in the music of Led Zeppelin. In the extensive body of scholarship on Judd's work, its critical aspects have been linked to its negation of received knowledge concerning the nature of art and the role of the artist, as well as its specific structural order, which suggests a mode of social organization in which hierarchy is displaced by a more egalitarian structure. Writing in 1976, for example, Dieter Koepplin cited Judd's interest in principles of free individualization within a given structure, noting that:

> The principal difference between any industrial object in the form of a box… and a work of Judd's, is that the artist uses on one side the general forms

of the artifacts of our present world and thereby automatically put himself in the context of our industrial civilisation… on the other hand he gives himself the freedom to realize in his work a clear form for principles which are sometimes opposed to those of our present society; principles of individualisation against unifying organization….[6]

More recently, R.E.H. Gordon has associated the non-narrative, non-symbolic aspect of Minimalism, as well as the blank monochrome surfaces of work by Judd, Morris, Fred Sandback and others, with a body that has presence but refuses definition and thereby escapes the categories of gender.[7]

In his challenge to Judd and Morris in "Art and Objecthood," Fried disparaged the "apparent hollowness" of the components that comprise their work, contending that the "quality of having an inside… is almost blatantly anthropomorphic," while inferring that hollowness signifies a lack of aesthetic substance.[8] Other critics have seen the quality of hollowness as a crucial aspect of Judd's work, its balance of shape and presence, and the continual shifting of the subject/object relationship—in which the viewer simultaneously perceives and is acted upon—to which Minimalism aspired. As Aaron Davis puts it, "It is in the hollowness that the work itself is manifest in its projection and definition of space outside of itself. If the works were themselves full, they would contain a subject beyond their boundaries and therefore remain static in time and site."[9]

MacLeod's *Stack* is marked by a comparable sense of hollowness, except here it's not about the enclosure of

1977 Camaro Rally Sport used in *Ramble
On*; London, Ontario, ca. 1978

empty space, but rather of being sonically flattened and emptied of sound. This resolute silence of *Stack*'s cabinets initiates an intermingling of real and literary time and begs the question of whether the performance has yet to begin or is already over, leaving the viewer suspended somewhere between anticipation and disappointment. This ambiguity is further complicated by a precise use of mimesis that dispenses with illusion, so there is no easily identified point where representation begins or ends. The relationship between artwork and viewer is indeterminate, but not completely open-ended; the scale of *Stack* dwarfs that of the viewer's body and if the absence of sound signals a decline in power within *Stack*'s grid, the potential to overwhelm the viewer remains. In the interval, the most pressing question seems to revolve around what processes produce and shape the desire the subject projects onto such a structure and what kind of agency such a structure leaves to the individual subject.

¶

I first encountered the writing of J.R.R. Tolkien at about the same time I became aware of Led Zeppelin. North American interest in *The Lord of the Rings* and *The Hobbit* had mushroomed in popularity by the late-1960s, and like millions of other readers, myself and most of my male friends anxiously followed the efforts of the somewhat juvenile hobbits and their more paternal companions to save Middle Earth from destruction. Although we were opposed to the ongoing war in Vietnam and Cold War militarism in general, we had no problem with the emphasis on battle in *The Lord of the Rings*. This was an epic conflict in which the terms were absolutely clear cut; there was only good and evil and taking an Orc prisoner was out of the question.

Tolkien's story had almost narcotic ability to transcend the limits of time and place and transport a reader from a small prairie city that seemed to have very little history into fantastic realms where myth was deeply rooted. For an adolescent raised in an Anglophilic environment, the picturesque Shire seemed simultaneously exotic and reassuringly English, a womb-like structure that was a perfect point of departure for adventure and transformation. With predictable Freudian desire, my friends and I fantasized about having magic swords with names like "Glamdring, the Foe Hammer" or "Orcrist, the Goblin Cleaver." I remember we generally identified with the hobbits, but aspired to the status of the more powerful characters. One of my taller

1977 Camaro Rally Sport used in *Ramble
On*; London, Ontario; ca. 2012

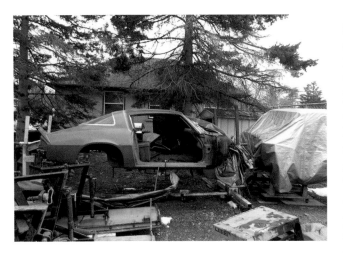

friends, who had long legs, was nicknamed Strider, a name
that, I learned later, he shared with Robert Plant's dog.
Initially, at least, I thought the references to *The Lord of the
Rings* in Led Zeppelin's lyrics were cool. At the time, the
combination of music in which sex played such a prominent
role and a tale that went well beyond 1,600 pages without
mentioning sex didn't seem odd to me. Neither did it seem
strange that in a story of such length women could have
almost no significant roles.

¶

MacLeod's sculpture *Ramble On* consists of two found
objects: a weathered 1977 Chevrolet Camaro Rally Sport—
from which the engine, transmission and much of the
interior has been removed—and a rusted steel stand on
which the car is mounted. The stand can be turned, allowing

the car to be rotated and its underbelly to be inspected,
appearing a bit like a carcass being roasted over a fire.
Introduced in 1967, the Camaro was General Motors' first
"pony car," a category of car established in 1964 with the
launch of the Ford Mustang. Pony cars were often based on
existing platforms but featured sporty styling—including
long hoods and bucket seats—that was targeted at a
relatively young and expanding North American middle
class eager to turn mundane commuting into adventure.
While the origins of the "muscle car" go back to the 1950s,
their popularity increased rapidly in the mid-to-late 1960s as
pony cars were fitted with ever-more-powerful engines and
Camaros, Mustangs and Barracudas came to be identified
with a specifically North American form of masculinity that
put raw power ahead of finesse and deliberately eschewed
the refinement of more expensive European cars like
Mercedes, Jaguars or Porsches. The muscle car's quest for
ever increasing horsepower came to an abrupt end in the
early 1970s, as regulations aimed at curbing air pollution and
rising gasoline prices brought on by the OPEC oil embargo
made high performance engines impractical and expensive
to operate. Consequently, when MacLeod's brother-in-law
purchased the 1977 Camaro Rally Sport used in *Ramble
On*, it was seen by some as a bit of an emasculated shell of
its former self. Nonetheless, it still had more than enough
power for cathartic release in the visceral pleasure of burning
rubber and spinning donuts at the local strip mall, perhaps
with Led Zeppelin blasting out of the car's cassette player.

Led Zeppelin's "Ramble On" appeared on the band's
second album, which was released in 1969. The song takes
pop music's theme of the "rambling man," a male protagonist

who is consumed by the search for something (usually an idealized woman) to compensate for a loss he's suffered (usually an idealized woman). "Ramble On" was the first Zeppelin song to include references to J.R.R. Tolkien's *Lord of the Rings*, a move that inserted the trope of the rambling man into the structure of the heroic quest, in which the protagonist ventures out of familiar territory and into strange lands where he encounters and eventually defeats supernatural beings. The song's lyrics evoke a setting that resembles Tolkien's Middle Earth, where the narrator's travels are tied to the cycles of the seasons ("Leaves are fallin' all around, time I was on my way") and his journey is guided by the light of the autumn moon. The song's opening line has been attributed to a poem Tolkien wrote in the elf language he invented, while the third verse refers to "days of old when magic filled the air" and reveals that the wound the narrator seeks to alleviate is the loss of his "girl so fair" to Gollum and the Evil One "in the darkest depths of Mordor." Speculation on the song's meaning has been a common preoccupation for Zeppelin fans; some have seen it as a re-telling of the story of Frodo Baggins' journey to destroy the Ring of Power and many have taken it as an allegory that can be related to lost love in their own lives. Given the song's references to travel and the repeated crescendos of musical power that mark the beginning of the chorus, it's not surprising that "Ramble On" is included in almost every list of top road trip songs posted on the internet.

MacLeod's use of the derelict Camaro links her work to that of John Chamberlain, the American artist who first became known in the late 1950s for sculptures he produced using materials from demolished cars. Scavenging metal parts from salvage yards, Chamberlain worked them into large-scale objects that possess the gestural character of Abstract Expressionism and hover in the terrain between abstraction and figuration. Chamberlain was a proto-Minimalist whose work played an important role in Judd's conceptualization of the specific object. He shared Judd's interest in industrial materials—although the scarred and beaten components of his work carry marks of prior use and bear little resemblance to Judd's pristine surfaces—while his intuitive assembly process contrasts acutely with the sense of order projected by Judd's. Nevertheless, the aspect of hollowness that is so crucial to Judd's work also plays a role in Chamberlain's sculpture, in which distended surfaces of repurposed steel encompass a porous interior and make it clear that no internal structure determines the work's outer configuration.

Taking a stance that paralleled Susan Sontag's assertion that, "In place of a hermeneutics we need an erotics of art,"[10] Chamberlain generally avoided intellectual analysis of his work. He distanced himself from mimetic readings that focused on the automobile as a signifier and vigorously dismissed suggestions that his use of material from wrecked cars was a metaphor for the wreckage of the American dream. He maintained his sculptures were "put together" rather than "smashed together" and attributed an erotic aspect to his instinct-driven assembly process, often stating, "The assembly is a fit, and the fit is sexual." As Gary Indiana put it in 1983, "The general impetus of the work is consciously sexual, not just in the snug interlocking of parts, but in the repetition of certain allusions, the deployment of unusually (and somewhat inexplicably) libidinal objects."[11] While Chamberlain's material vocabulary of scrapped

steel, together with the auto wrecking yards from which it was sourced, is without question masculinized, it has been argued that his working process is not entirely fixed in its construction of gender or sexuality. David Getsy, for example, has drawn upon transgender theory to cogently argue that the parts in Chamberlain's work can't be readily identified as male or female, nor can the activity of fitting them together be reduced to a process of penetration or reception. Echoing Fast's association of the carnivalesque with the performances of Led Zeppelin, Getsy has associated this ambiguity in Chamberlain's work with an embodiment of the immoderate, a sense of excess in which: "A line has been crossed, and that which is normally kept out of bounds is welcomed in…. Immoderation is a tactic… like coupling, in which boundaries are blurred or folded over."[12]

A process of subtraction, rather than coupling, marks MacLeod's *Ramble On*. This Camaro wasn't crushed in a wrecking yard; it mouldered in a suburban backyard, perhaps exhausted after years of immoderation on the part of its owner. It's easy to imagine the Camaro's missing doors ending up in one of Chamberlain's sculptures, but there's nothing here of Chamberlain's sense of regeneration, in which steel becomes a kind of "manure" that goes from being "the waste material of one being to the life-source of another."[13] Instead there is a playful teasing of the tenets of Minimalism and the debate they generated. The insertion of the disintegrating Camaro into the space of the gallery can be seen as confirmation of Fried's fear that the theatricality of Minimalism will make it ever more difficult to distinguish the artwork from any other kind of object. The process of hollowing out the Camaro into an empty shell can be seen as both a performance of Minimalism's emphasis on the surface of the artwork as the location of meaning and a breach of Minimalism's aversion to external content.

Ramble On is marked by a sense of emptiness much like that which pervades *Stack*. But, unlike *Stack*, the intermingling of literal time and real time in *Ramble On* holds no sense of anticipation, as any possibility of a future performance is precluded by the apparently permanent deletion of the source of the Camaro's power. This deficit is amplified by the placement of the hollowed out car body on the rotisserie/stand, a shift that effects a spatial reconfiguration in which the association of power with the interior of the car, where it was at the disposal of the driver, is transferred to the space outside the car, occupied by the viewer, which is now the only position from which the Camaro's shell can be moved. As with *Stack*, this shift in equilibrium invites consideration of the construction of desire and the status of the viewer as both subject and object. However, the sense of depletion, rather than suspension, of power in *Ramble On* places additional emphasis on the way the viewer is located by the work, the assumption of a sexually indifferent subject in Minimalism's embrace of phenomenology and the point at which visceral excess and immoderation might shift from indulgence to transgression.

¶

I lost interest in Tolkien's writing at about the time I got my driver's license. The vehicle I drove was my mother's Volkswagen Beetle, so my attention wasn't diverted by the thrills of a high-powered Camaro or Mustang. It had more to

do with the way the idealism of Tolkien's characters became tedious, while their chivalric codes seemed constricting and had little relevance to contemporary life. In comparison, the world view proposed in Harvard Lampoon's *Bored of the Rings* was much more plausible and promised more fun. *Bored of the Rings* followed the general drift of Tolkien's story, but changed the setting to a world inhabited by spaced-out stoners, where most things were broken or falling apart and nature was thoroughly degraded. *Bored of the Rings'* characters were lifted from Tolkien's stories, but were given new names that were more in keeping with the book's setting: Bilbo Baggins of Bag End became Dildo Bugger of Bag Eye, Frodo Baggins became Frito Dildo, Tom Bombadil became Tim Benzedrene, Gandalf became Goodgulf Grayteeth and the Orcs became narcs. A few features were added to Tolkien's map of Middle Earth; these included The Bay of Milhous, a body of water that resembled the head of Richard Nixon.

I can't recall anything in *Bored of the Rings* that could be equated with the "profane illumination"—with its revolutionary potential for transcendence in a kind of ecstatic union of the profane and the metaphysical—that Walter Benjamin sought in the consumption of hashish. But maybe it was there and I just missed it.

¶

MacLeod's *Albert Walker* is made up of twelve oversized marijuana buds modelled in nylon by a three-dimensional digital printer, a method of fabrication that can produce a series of intricately shaped objects more economically and in less time than the methods that were available to Judd.

Each bud has been given several coats of "chameleon paint," a product developed primarily for automobiles that changes colour depending on the angle from which it's seen. The buds are housed in an unfinished, oversized "entertainment centre"—a piece of furniture commonly found in middle-class homes that holds televisions, sound systems and family photographs, and that vaguely echoes the structure of Judd's late wall works.

The use of commercial paint and the serial production of the twelve buds is another allusion to Judd's work, especially the works from the late 60s and early 70s that incorporate fluorescent Plexiglas and seem to emanate light. As with *Stack*, *Albert Walker* acknowledges a debt to Judd while taking a parodic stance in relation to his work, particularly through its use of a paint that changes colour with a shift in viewpoint—a move that was perhaps calculated to thwart Judd's desire to "have all the colours present at once" in his later, multi-coloured work.[14]

MacLeod's sculpture takes its title from a strain of marijuana named after a notorious Canadian criminal. Albert Walker is a disgraced financier who defrauded Canadian investors of millions during the 1980s, fled to England in 1990 and eventually murdered a friend whose identity he had assumed. He was convicted of murder in 1998 and later pleaded guilty to fraud, theft and money laundering. His notoriety was heightened further when it was revealed Walker and his daughter had been posing as husband and wife while he was a fugitive, and that his daughter had given birth to two children during that time. By most accounts Walker was a chameleon-like character; he was affable, made friends easily and seemed nothing like

a con man or murderer. Prior to leaving Canada he lived in Paris, Ontario where he regularly attended church, sang in the choir and projected an aura of trust that convinced dozens of people to let him manage their finances through his company, Walker Financial. The variety of marijuana called "Albert Walker" is described as "a very strong, mood elevating and relaxing indica."[15] It can reproduce only through cloning and its origins are uncertain, although it's thought by some to have been derived from "Afghan skunk." Apparently the most common flavours associated with Albert Walker marijuana are "citrus, tangerine and grapefruit combined with a subtle aftertaste of kerosene or fuel."[16] Why it was named after a heinous criminal is a matter for speculation, though one possible explanation is that the difficulty of identifying the origin of the strain is the effect that its namesake was after in his efforts to obscure his own origins while he was on the run.

MacLeod's use of a form derived from a consciousness-altering substance runs counter to what Jörg Heiser has described as Judd's "assertion of soberness." As Heiser has pointed out, Judd deployed a restrained sobriety in his work as:

> … a strategic detachment from the previous generation of artists. While he certainly admired the paintings of Barnett Newman, Jackson Pollock, Mark Rothko and Clyfford Still, he also saw himself as succeeding them, replacing their abstract evocations of the sublime within the constraints of the picture plane with the deadpan constructed object that bypassed both those evocations and those constraints.

Within this context, the construction of desire that permeates the chameleon-painted Albert Walker buds is "exactly what Judd wanted to get away from."[17]

This tension between sobriety and desire is central to MacLeod's practice. This is not to say her work is about satirical takes on the canon of Minimalism, which would be of very limited interest, but that the contradictions embodied in Judd's work—the conflict between his reconfiguration of the role of the artist, the emphasis on the encounter between viewer and artwork, and the impossibility of isolating his materials from the associations they carry with them—are both inherent to art making and emblematic of the contradictions that underlie a much broader set of social structures through which desire is projected, identity is formed and power is exerted. In its negotiation of terrain in which disparate manifestations of culture intersect, MacLeod's work draws us into an extended consideration of the shifting boundaries that define excess and escapism, agency and acculturation, visceral release and interpellation, meaning and meaninglessness, while at the same time raising the question of what possibilities their permeability might allow us as subjects.

Endnotes

1 I don't recall hearing the term "garage band" until the 1980s. Even if the term was in use in the early seventies, it didn't fit the Saskatoon situation where, due to the severe climate, it was too cold to play in a garage for at least half the year.

2 Donald Judd, cited in Briony Fer, *On Abstract Art* (New Haven and London: Yale University Press), 1997, p. 144.

3 Donald Judd, in "Specific Objects," in *Donald Judd: Complete Writings 1959-1975* (Halifax: Nova Scotia College of Art and Design; New York: New York University Press), 1975, p. 184.

4 Judd, "Specific Objects," pp. 181–89.

5 Susan Fast, *In the Houses of the Holy: Led Zeppelin and the Power of Rock Music* (New York: Oxford University Press), 2011, p. 6.

6 Dieter Koepplin, in *Donald Judd Zeichnungen/Drawings 1956–1976* (Basel: Basel Kunstmuseum), 1972, p. 9.

7 See R.E.H. Gordon, "Object Lessons—Thinking Gender Variance Through Minimalist Sculpture," a paper presented at the 2013 College Art Association Conference in a panel titled *Sexing Sculpture: New Approaches to Theorizing the Object*. Available online at: *gordonhall.net/files/REH_Gordon_Object_Lessons_.pdf*.

8 Michael Fried, "Art and Objecthood," in *Minimal Art: A Critical Anthology*, Gregory Battcock ed. (New York: E.P. Dutton & Co.), 1968, p. 129.

9 Aaron Davis, "'What You See is What You See': Constructing the Subject-Object," at www.artandeducation.net/paper/"what-you-see-is-what-you-see"-constructing-the-subject-object/.

10 Susan Sontag, "Against Interpretation," in *Against Interpretation and Other Essays* (New York: Dell Publishing Co.), 1966, p. 14.

11 Robert Indiana, "John Chamberlain's Irregular Set," in *Art in America* 71, No.10, 1983, p. 212.

12 David Getsy, "Immoderate Couplings: Transformations and Genders in John Chamberlain's Work" in *It's All in the Fit: The Work of John Chamberlain* (Marfa: The Chinati Foundation), 2009, p. 182.

13 John Chamberlain, from an unpublished 1981 interview with Michael Auping, cited in Auping, "John Chamberlain: Reliefs 1960–1982," in *John Chamberlain: Reliefs 1960—1982* (Sarasota: John and Mable Ringling Museum of Art), 1983, p. 12. This phrase is widely cited in discussions of Chamberlain's work.

14 Donald Judd, *Some aspects of color in general and red and black in particular* (Sassenheim: Sikkens Foundation), 1993, pp. 26–28.

15 See *Medical Marijuana Guide* at: MMj-Guide.com/index.html.

16 See *Medical Marijuana Guide* at: MMj-Guide.com/index.html.

17 Jörg Heiser, "Surface Tension," in *Kaleidosope*, at: kaleidoscope-press.com/issue-contents/surface-tension-words-by-jorg-heiser/.

YOU BEEN COOLIN'
AND BABY I'VE BEEN DROOLIN'

ALL THE GOOD TIMES BABY I'VE
BEEN MISUSIN'-A

A-WAY DOWN INSIDE

I'M GONNA GIVE YA MY LOVE, AH

I'M GONNA GIVE YA EVERY INCH OF
MY LOVE, AH

YES, ALRIGHT, LET'S GO.

Drawings from MacLeod's *Whole Lotta
Love*, an artist's book published by
Publication Studio Vancouver and Slade
Editions, 2012

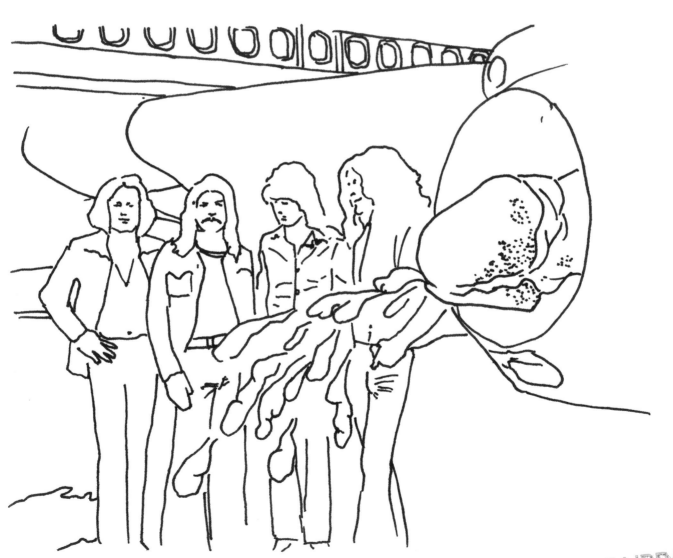

SPECIFIC OBJECTS, PROFANE ILLUMINATION

OPPOSITE
Living in the Past, 1981–2009
inkjet print on watercolour paper, frame
50 x 38 cm
Courtesy Catriona Jeffries Gallery

Image of a marijuana plant from the
strain known as 911, photograph by
Myfanwy MacLeod, 2004

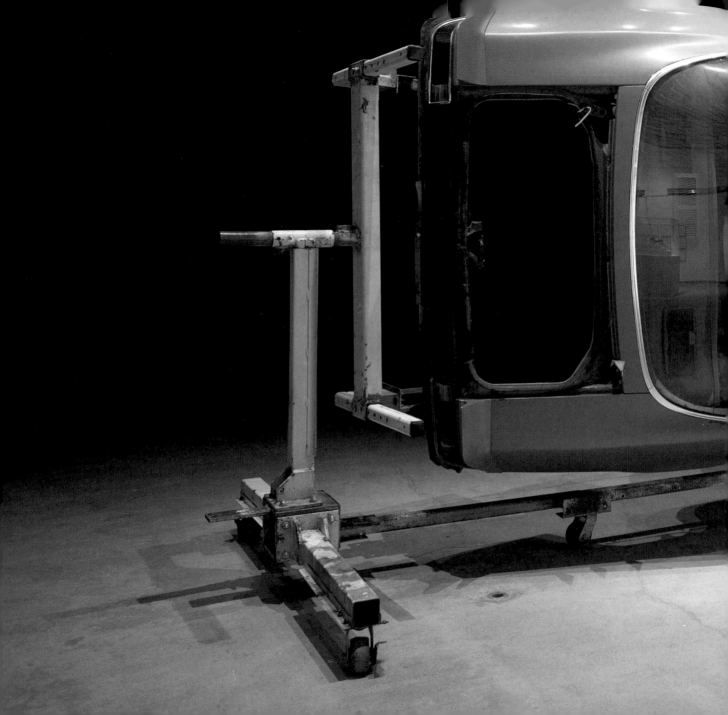

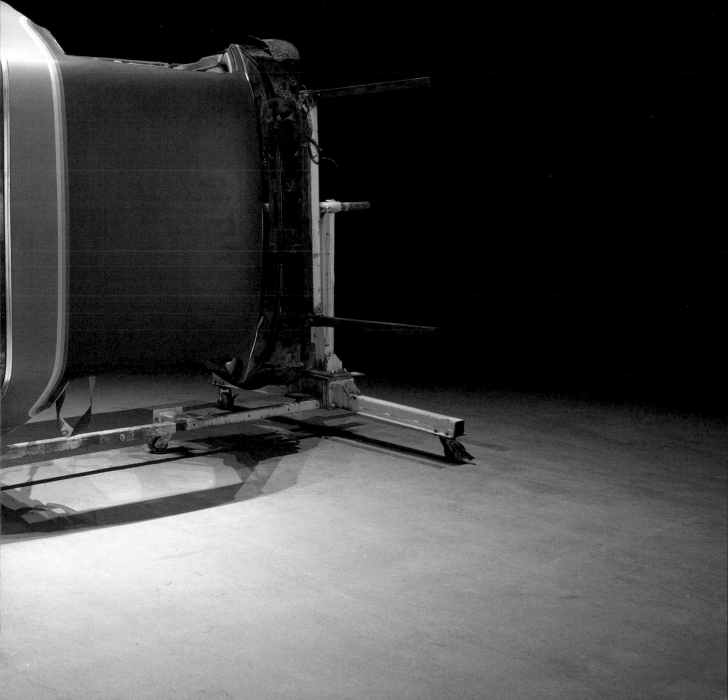

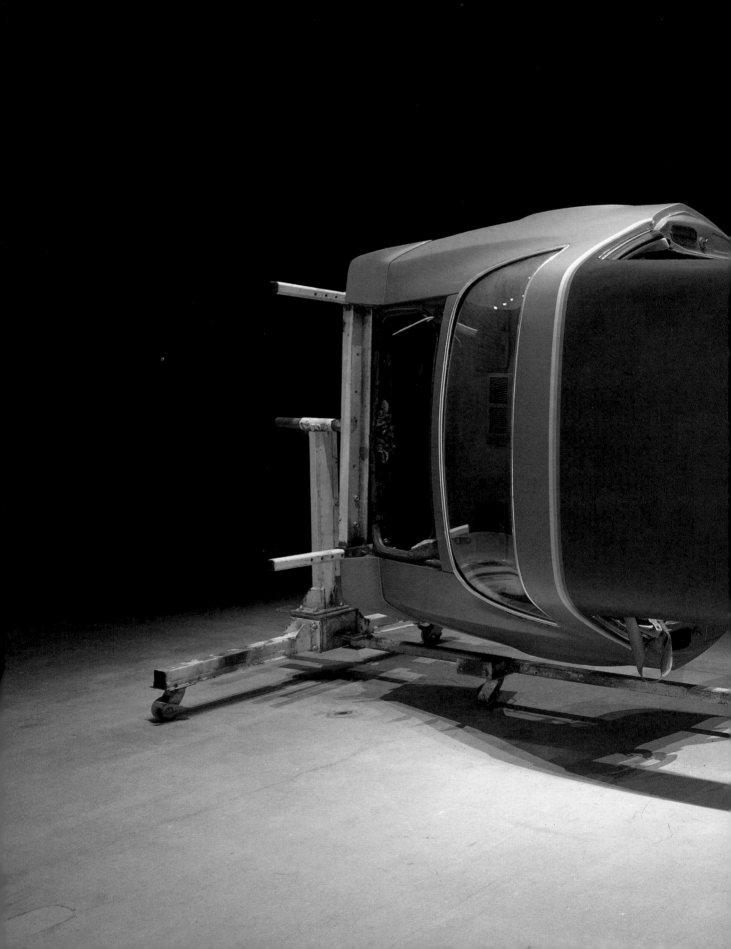

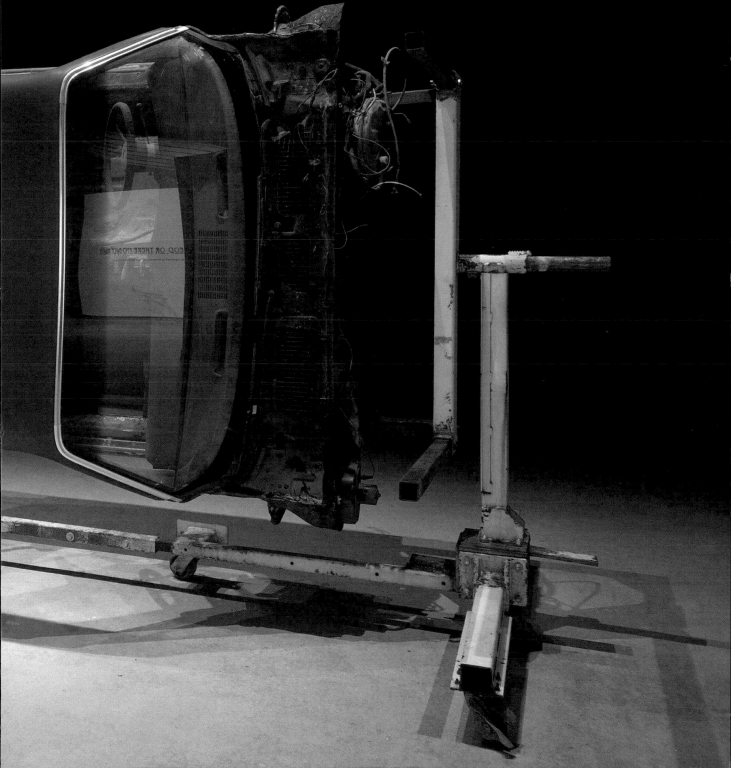

PP. 112–115
Ramble On, 2013
1977 Camaro Rally Sport, steel stand
221 x 493 x 176 cm
Courtesy Catriona Jeffries Gallery

Ramble On, 2013 (detail)
1977 Camaro Rally Sport, steel stand
221 x 493 x 176 cm
Courtesy Catriona Jeffries Gallery

OPPOSITE
Living Loving Maid (She's just a woman),
2013
mannequin, Led Zeppelin T-shirt,
beer cans
122 x 41 x 28 cm
Courtesy Catriona Jeffries Gallery

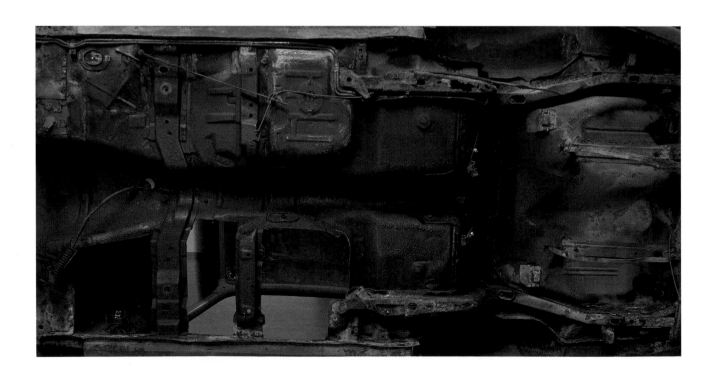

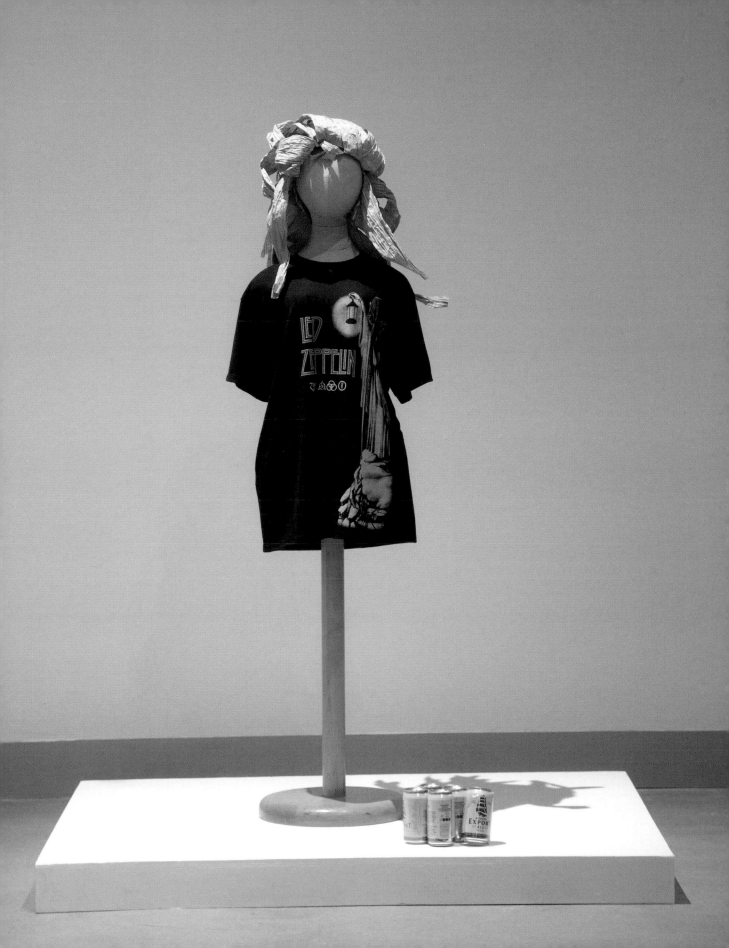

PP. 118–119
The Dragon, 2014
photomural on paper
dimensions variable
Courtesy Catriona Jeffries Gallery

OPPOSITE
Marijuana bud from *Albert Walker*, 2014
3D printed nylon, chameleon paint,
medium density fibreboard, Plexiglas,
light fixtures
244 x 305 x 46 cm
Courtesy Catriona Jeffries Gallery

Albert Walker—an Account

Albert Walker is a prized strain of marijuana associated with the Pacific Northwest of North America.
A medium-sized plant that is difficult to grow, its harvest is said to produce a euphoric and long-lasting
high while increasing energy and mental clarity. The strain is also known for its unique flavour, which
is "tangy yet semi-rotten, almost menthol-like and not quite astringent, but something close," while its
aroma "reeks of lemony roadkill skunk."[1] Considered an "elite cut," Albert Walker is very rare. It can
only be reproduced through cloning and its origins are uncertain, though it's generally thought to have
a connection to Afghanistan.

The strain was named after an infamous Canadian criminal. Originally from Paris, Ontario, Albert
Johnson Walker was a high school dropout who eventually established his own financial company, which
ran into problems in the mid-1980s when a stock deal he had invested in collapsed. Walker transferred his
clients' money into secret accounts in Europe and the Cayman Islands and fled to England with Sheena,
the second of his three daughters, in 1990. He changed his name to David Davis and started a business
with a Canadian-born television repairman named Ronald Platt. With financial assistance from Walker,
Platt returned to Canada in 1992. Walker then assumed Platt's identity and had Sheena pose as his wife.
By this time, Canadian police had uncovered Walker's appropriation of his client's funds and, in 1993,
charges related to the theft were laid against him.

Platt ran out of money and returned to England in 1995. Realizing his assumed identity was about to be
exposed, Walker invited Platt to go on a fishing trip, murdered him and dumped his weighted body into
the English Channel. The body was dredged up by fishermen two weeks later. It carried no identification,
but police eventually determined Platt's identity through the serial number on his Rolex wristwatch and
ultimately exposed Walker's scheme. He was convicted of Platt's murder in 1998. Walker's notoriety was
heightened when it was learned that Sheena had given birth to two children during their time in England.
The paternity of the children has not been determined. Walker was transferred to a Canadian prison in
2005 and was convicted of fraud, theft and money laundering.

The names given to strains of marijuana are often romantically poetic (Leda Uno, Scheherazade, Mountain
Mist) or refer to the potency of their power to alter consciousness (Dr Atomic Strains, Triple Afghan
Slam). Some refer to popular media culture (Jedi) and a few are named after living people (Willie Nelson).
Albert Walker seems unique in this pantheon, as it's the only strain mentioned in the literature on
marijuana that takes its name from such an odious source. We can't be certain of the motive behind such
a move, but it does evoke curiosity about the sense of irony involved in naming a hybrid clone associated
with a euphoric state of mind after a con artist and murderer.—GA

1 Jason King, *The Cannabible 3* (Berkeley: Ten Speed Press), 2006, p. 25.

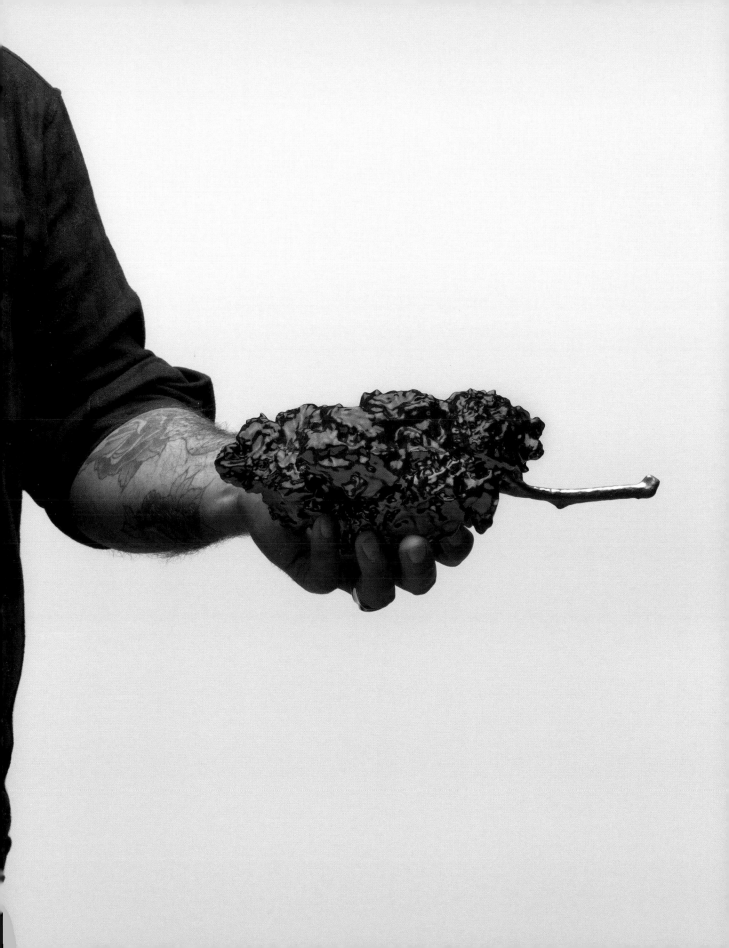

Ronald Platt, murder victim of Albert Walker. Photo courtesy of Devon and Cornwall Constabulary

Albert Walker, murderer and fraud artist. Photo courtesy of the *Toronto Star*

OPPOSITE
Ronald Platt's Rolex watch, which allowed police to identify his body

b. 1961, London, Ontario
Lives and works in Vancouver

Selected solo exhibitions

1990 *The Secret Garden*, The Whitehall, London, Ontario
1995 *The Fountainheads*, Access Gallery, Vancouver
1997 *My Idea of Fun*, Or Gallery, Vancouver
2000 *A Brief Overview of Personology*, Charles H. Scott Gallery, Vancouver
How Not to Be Seen, VTO Gallery, London, England
2001 *The Tiny Kingdom*, Or Gallery, Vancouver
myfanwy macleod: miss moonshine, Catriona Jeffries Gallery, Vancouver
2004 *Don't Stop Dreaming*, Catriona Jeffries Gallery, Vancouver
2006 *Where I Lived, and What I Lived For*, Contemporary Art Gallery, Vancouver
2009 *Gold*, Catriona Jeffries Gallery, Vancouver
2012 *Dorothy*, Presentation House Gallery Satellite, Vancouver
2013 *Myfanwy MacLeod, or There and Back Again*, Museum London, London, Ontario
2014 *Myfanwy MacLeod, or There and Back Again*, Vancouver Art Gallery
The Last Drop, BMO Project Room, Toronto

Selected Group Exhibitions

1995 *Sexsells*, Western Front Gallery, Vancouver
1996 *Topographies: aspects of recent BC art*, Vancouver Art Gallery
Endless Summer, Anna Leonowens Gallery, Halifax
1997 *Browser*, The Roundhouse, Vancouver
Cells and Stills, Trylowsky Gallery, Vancouver
Framed, Or Gallery, Vancouver
1998 *Objects for the Ideal Home*, Art Metropole, Toronto
6: New Vancouver Modern, Morris and Helen Belkin Art Gallery, Vancouver
1999 *Universal Pictures II*, Monte Clark Gallery, Vancouver
Universal Pictures, Australian Centre for Contemporary Art, Melbourne International Biennial, Melbourne
Recollect, Vancouver Art Gallery
2000 *On Location: Public Art for a New Millennium*, Vancouver Art Gallery, Vancouver
Double Whammy, Atelier Gallery, Vancouver
2001 *These Days*, Vancouver Art Gallery, Vancouver
Universal Pictures, Blackwood Gallery, Mississauga
Universal Pictures 3.1, Plug In Gallery, Winnipeg
2002 *Officina America*, Villa delle Rose, Bologna
Think Big/Voir grand, Saidye Bronfman Centre for the Arts, Montreal
Beachcombers, Gasworks, London, England and Middlesborough Art Gallery
Hammertown, Fruitmarket Gallery, Edinburgh
Bounce, The Power Plant Contemporary Art Gallery, Toronto
2003 *Comic Release! Negotiating Identity for a New Generation*, Regina Gouger Miller Gallery, Carnegie Mellon University, Pittsburg and New Orleans Contemporary Arts Center, New Orleans
Hammertown, Bluecoat Gallery, Liverpool
Beachcombers, Mead Art Gallery, University of Warwick, Coventry
ReDefining the LaLaLaLandscape, Helen Pitt Gallery, Vancouver
I Sell Security, Catriona Jeffries Gallery, Vancouver
Bounce, Bellevue Art Museum, Bellevue
Drawing the World: Masters to Hipsters, Vancouver Art Gallery
Seethe, Catriona Jeffries Gallery, Vancouver
2004 *re(framed) locations, dis(covered) desires: invading the personal & erasing communications errors*, Laznia Centre for Contemporary Art, Gdansk
Strips & Characters, Kunstverein Wolfsburg
Four X Four, Durham Art Gallery
2005 *Intertidal: Vancouver Art and Artists*, Museum van Hedendaagse Kunst, Antwerp

Mix with Care, Catriona Jeffries Gallery, Vancouver
2006 *Telling Stories*, Agnes Etherington Art Centre, Kingston
274 East 1st, Catriona Jeffries Gallery, Vancouver
Make Believe, Art Gallery of Alberta, Edmonton
Prototype: Contemporary Art from Joe Friday's Collection, Carleton University Art Gallery, Ottawa
2007 *The Banal*, SBC Galerie d'art contemporain, Montreal
2008 *Keep the IS in FEMINISM*, Contemporary Art Gallery, Vancouver
Stories, in Pieces, Justina M. Barnicke Gallery, Toronto
Spectral Muse, Confederation Centre for the Arts, Charlottetown
2009 *Loaded*, Catriona Jeffries Gallery, Vancouver
Nomads, National Gallery of Canada, Ottawa
2010 *Cue: Artist's Videos*, Vancouver Art Gallery, Vancouver
2011 *Myfanwy MacLeod, William Hogarth: Miscreants and Reprobates*, Charles H. Scott Gallery, Vancouver
2012 *Oh Canada*, Mass MoCA, North Adams, Massachusetts
Builders: Canadian Biennial 2012, National Gallery of Canada, Ottawa
2013 *14: Climate is Culture*, Royal Ontario Museum, Toronto

Commissions

The Birds, public artwork commissioned by the City of Vancouver through the Olympic and Paralympic Public Art Program, 2010

Books and Exhibition Catalogues

topographies: aspects of recent BC art. Vancouver: Vancouver Art Gallery, 1996. (Essays by Grant Arnold, Monika Kin Gagnon and Doreen Jensen)
6: New Vancouver Modern. Vancouver: Morris and Helen Belkin Art Gallery, 1998. (Essays by Patrik Andersson & Shannon Oksanen, Sharla Sava, Reid Shier, Michael Turner and Scott Watson)
Signs of Life. Melbourne: Melbourne International Biennial, 1999. (Essay by Kitty Scott)
Myfanwy MacLeod: A Brief Overview of Personology. Vancouver: Charles H Scott Gallery, 2000. (Essay by Kathy Slade)
myfanwy macleod: miss moonshine. Vancouver: Catriona Jeffries Gallery, 2001. (Essay by Reid Shier)
Universal Pictures 3. Mississauga: Blackwood Art Gallery, 2001. (Essay by Barbara Fischer)
Bounce. Toronto: The Power Plant Contemporary Art Gallery, 2002. (Essay by Phillip Monk)
The Beachcombers. London: The Drawing Room, 2002. (Essay by Andrew Renton)
Hammertown. Edinburgh: The Fruitmarket Gallery, 2002. (Essays by Reid Shier and Michael Turner)
Comic Release! Negotiating Identity For A New Generation. Pittsburgh: Regina Gouger Miller Gallery at Carnegie Mellon University and the Pittsburgh Center for the Arts, 2003. (Essays by Vicky A. Clark, Barbara J. Bloemink, Ana Merino and Rick Grebanas)
For the Record: Drawing Contemporary Life. Vancouver: Vancouver Art Gallery, 2003. (Essay by Daina Augaitis)
Four X Four. Durham: Durham Art Gallery, 2004. (Essay by Stuart Reid)
re:location 6: re(framed) locations, dis(covered) desires: ukryte pragnienia. Gdansk: Laznia Centre for Contemporary Art, 2004. (Essay by Adam Budak)
Intertidal: Vancouver Art and Artists. Antwerp and Vancouver: Museum van Hedendaagse Kunst, Morris and Helen Belkin Art Gallery, 2005. (Essays by Dieter Roelstraete, Reid Shier, Shepherd Steiner, Monika Szewczyk, Michael Turner, Ian Wallace, Scott Watson and William Wood)
Prototype: Contemporary Art from Joe Friday's Collection. Ottawa: Carleton University Art Gallery, 2006. (Essay by Germane Koh)
Myfanwy MacLeod—Where I lived, and What I lived For. Vancouver: Contemporary Art Gallery, 2006. (Essays by Connie Butler, Francis Mckee and Jenifer Papararo)
Stories in Pieces. Toronto: Justina M. Barnicke Gallery, 2008. (Essay by Aileen Burns)
Nomads. Ottawa: National Gallery of Canada, 2009. (Essay by Josée Drouin-Brisebois)
Oh Canada. Markonish, Denise ed. Cambridge: MIT Press, 2012.

Magazines and Periodicals

McCrum, Phil and Reid Shier. "Just Looking," *Boo Magazine* 2, October–November 1994, p. 5.

Blair, Jennifer. "The Fountainheads," *Artichoke Magazine,* Spring 1996, pp. 40–41.

Milroy, Sarah. "Primeval meets postmodern in BC show," *The Globe and Mail*, 28 September 1996.

Scott, Michael. "BC Artists Emerge in Topographies," *The Vancouver Sun,* 29 September 1996.

Robert, Everett Green. "Gallery hopping takes on a whole new dimension," *The Globe and Mail,* 7 November 1996.

Brayshaw, Christopher. "Topographies more valleys than peaks," *The Vancouver Courier,* 27 November 1996.

Mastai, Judith. "The Elevation of BC Art," *C Magazine* 52, February–April 1997, pp. 24–27.

Gaché, Sherry. "topographies," *Sculpture,* vol. 16 no. 4, April 1997, pp. 62–63.

Gault, Charlotte Townsend. "Topographies: Aspects of Recent BC Art," *Canadian Art,* Spring 1997, pp. 68–71.

Knode, Marilu, "New Vancouver Art: Deliberately Pushy," *Art/Text* 59, November 1997, pp. 47–49.

Milroy, Sarah. "An eyeful of irony," *The Globe and Mail,* 14 February 1998.

Scott, Michael. "Little to show from 6 new artists," *The Vancouver Sun,* 21 February 1998.

Laurence, Robin. "Slacker Generation Artists Take out the Pop Culture Trash," *The Georgia Straight,* 5–12, March 1998, p. 52.

Williams, Paul. "Looking for the Buzz," *Artfocus,* vol. 6 no. 2, Spring/Summer 1998, p. 20.

Lum, Ken. "Six: New Vancouver Modern," *Canadian Art,* vol. 15 no. 2, Summer 1998, pp. 46–51.

Mark, Lisa Gabrielle. "Letter from Toronto," *C Magazine* 59, Winter 1998, p. 377.

Birnie, Peter, "Shadbolt's gifts honour local artists," *The Vancouver Sun,* 24 March 1999.

Scott, Michael. "Pop culture through the camera's eye," *The Vancouver Sun,* 16 September 1999.

Laurence, Robin. "Young Artists Cull Pop-Culture Kitsch," *The Georgia Straight,* 24–30 September 1999, p. 109.

Gopnik, Blake. "Crossing the line between past, future," *The Globe and Mail,* 26 October 1999.

Laurence, Robin. "Scary Mascots, Super Art," *The Georgia Straight,* 22–29 June 2000, p. 79.

Hodgson, Liz. "On Location: Public Art for the New Millennium," *The Vancouver Sun,* 6 July 2000.

Brayshaw, Christopher. "Curator's words undermine cartoon and TV-inspired work," *The Vancouver Courier,* 19 September 2000.

Scott, Michael. "Art of global importance," *Vancouver Sun,* 5 March 2001.

Coupland, Douglas. "Critical Mass," *Globe and Mail,* 12 May 2001.

Mahovsky, Trevor. "Radical, Bureaucratic, Melancholic, Schizophrenic: Texts as Community," *Canadian Art,* vol. 18 no. 2, Summer 2001, pp. 50–56.

Turner, Michael. "Review: These Days," *Mix,* vol. 27 no. 2, Autumn 2001, pp. 48–50.

Roy, Marina. "These Days," *Last Call,* vol. 1 no. 2, Autumn 2001, pp. 2–4.

Laurence, Robin. "The world according to Myfanwy," *Globe and Mail,* 3 November 2001.

Laurence, Robin. "VAG Takes Art Outdoors," *Georgia Straight,* 15–21 November 2001, p. 69.

Hayes, Kenneth. "Universal Pictures 3 at the Blackwood Gallery," *Mix,* vol. 27 no. 3, Winter 2001, pp. 44–46.

Wyman, Jessica. "Review: Universal Pictures 3," *C Magazine* 72, Winter 2001, p. 43–44.

Brayshaw, Chris. "Review: Myfanwy MacLeod," *C Magazine* 72, Winter 2001, p. 42.

Culley, Peter. "The Night of a Thousand Bees and What Happened Afterward: Swarm 2," *Last Call,* vol. 1 no. 3, Spring 2002, pp. 6–7.

Stoffman, Judy. "Whale skeleton emerges from lawn chair closet," *The Toronto Star,* 17 June 2002.

Milroy, Sarah. "A tale of two art worlds," *Globe and Mail,* 20 June 2002.

Brayshaw, Christopher "Glyptomania," *Georgia Straight,* 15–22 August 2002, p. 69.

Dale, Paul. "Hammertown," *Time Out,* 3 October 2002.

Todd, Jeremy. "Glyptomania," *Canadian Art,* vol. 19 no. 4, Winter 2002, p. 84.

Brayshaw, Christopher. "Security and Anxiety Post-9/11," *The Georgia Straight,* 5–12 June 2003, p. 56.

Scott, Michael. "Following the Lines," *Vancouver Sun,* 26 June 2003.

Huester, Wiebke. "Da ist die junge Kunst, die sich der Natur zuwendet," *Frankfurter Allgemeine Zeitung,* 4 October 2003.

Laurence, Robin. "Drawing the World," *Border Crossings,* vol. 22 no. 4, November 2003, pp. 100–102.

Gandesha, Samir. "Vancouver, British Columbia," *Art Papers,* November–December 2003, p. 61.

Laurence, Robin. "Dreaming is a sound exercise in frustration," *The Georgia Straight,* 23–30 September 2004, p. 48.

"Kunst und Comics: Ausstellung im Schloss," *Wolfsburger Allgemeine Zietung,* 26 November 2004.

Von Karweik, Hans Adelbert. "Kunst unterm einfluss der Comics," *Wolsberger Nachrichten,* 26 November 2004.

Von Karweik, Hans Adelbert. "Marsmannchen treffen Marchenfrosche," *Wolfsburger Nachrichten,* 1 December 2004.

Von Buhr, Elke. "Der SupermanEffekt," *Frankfurter Rundschau,* 28 December 2004.

Burnham, Clint. "Aperto Vancouver," *Flash Art,* vol. XXXVII no. 239, November–December 2004, pp. 57–59.

Campbell, Deborah. "Once Upon a Time," *Canadian Art,* vol. 22 no. 1, Spring 2005, pp. 70–74.

Dault, Julia. "F Stopping the Slide into Self Repetition," *The National Post,* 19 January 2006.

Burnham, Clint. "Artist crosses the frontiers between different media," *The Vancouver Sun,* 2 February 2006.

Inwood, Damian. "Beware the (slightly) open door," *The Province,* 26 February 2006.

Campbell, Deborah. "Pop Pastoral," *Vancouver Review,* no. 9, Spring 2006, pp. 6–9.

Laurence, Robin. "Micah Lexier, Myfanwy MacLeod, Andrew Reyes," *The Georgia Straight,* 2–8 March 2006, pp. 46–47.

Burnham, Clint. "Artworks challenge and intrigue," *The Vancouver Sun,* 3 June 2006.

Dault, Julia. "A Room of One's Own," *The National Post,* 15 June 2006.

Culley, Peter. "The Ghost Whisperer," *Fillip,* vol. 1 no. 3, 2006, p. 1.

Milroy, Sarah. "Artists in a Land of Wanderers," *The Globe and Mail,* 25 April 2009.

Griffin, Kevin. "Sparrows to Invade Olympic Village," *Vancouver Sun,* 12 July 2009.

Falvey, Emily. "Nomads," *Canadian Art,* vol. 26 no. 3, Fall/September 2009, p. 164.

Laurence, Robin. "Folk and High Art Make Wondrously Strange Mix," *The Georgia Straight,* 26 November–1 December 2009, p. 58.

Egan, Danielle. "Myfanwy MacLeod: Big Birds," *Canadian Art,* Spring 2011, pp. 70–73.

Lederman, Marsha. "Playmate Dorothy Stratten's story, told in origami," *The Globe and Mail,* 9 October 2012.

Belanger, Joe. "On the canvas: Former Londoner's idealism on display," *The London Free Press,* 5 May 2013.

McLaughlin, Bryne. "Myfanwy MacLeod Revisits 1970s London in Bittersweet Survey," *Canadian Art* online, 5 July 2013.

Writing by Myfanwy MacLeod

MacLeod, Myfanwy. *Boo Magazine* 5, 1995.

MacLeod, Myfanwy. "Artist talks to the Artist," *Vancouver Sun,* 5 February 2004.

MacLeod, Myfanwy. "Just Kidding: Kyla Mallett," (catalogue essay), Vancouver: Catriona Jeffries Gallery, 2004.

MacLeod, Myfanwy. "Just Kidding: Kyla Mallett," *Canadian Art,* Summer 2004, pp. 54–56.

Pages 8, 20–21, 24–25, 26–27, 44, 46, 56–57, 58, 59, 62–63, 64, 65, 66, 67, 68–69, 70, 71, 72, 73, 86–87, 88–89, 99, 100, 108, 109, 121
Trevor Mills and Rachel Topham, Vancouver Art Gallery

Page 11
Courtesy of the Morris and Helen Belkin Art Gallery, Vancouver

Pages 12, 38–39, 40–41, 42, 43, 50
Scott Massey, Courtesy of Catriona Jeffries Gallery, Vancouver

Page 14
Robert Keziere

Pages 17, 18–19, 90–91, 112–113, 114–115, 116, 117
Steve Martin, Thompson Martin Photography, London

Pages 22–23, 110, 111, 118–119
Myfanwy MacLeod

Pages 28, 32
Courtesy of the National Gallery of Canada, Ottawa

Page 37
Toni Hafkenscheid

Pages 60–61
Courtesy of Presentation House Gallery, North Vancouver

Pages 101, 102
Chris Specht

NOTES ON CONTRIBUTORS

Grant Arnold is the Audain Curator of British Columbia Art at the Vancouver Art Gallery. He has organized more than sixty exhibitions of historical, modern and contemporary art for the Gallery. Recent projects include *In Dialogue with Carr: Gareth Moore—Allochthonous Window*; *Spiritlands: (t)HERE: Marian Penner Bancroft Selected Photo Works 1975–2000*; *Traffic: Conceptual Art in Canada 1965–1980* (with Catherine Crowston, Barbara Fischer, Michèle Theriault and Vincent Bonin, and Jayne Wark).

Brady Cranfield is a Vancouver-based artist, musician and instructor with an avid interest in sound and music. He is the Founder and Co-director (with Kathy Slade) of the ongoing public art project *The Music Appreciation Society*, and he frequently collaborates with artist Jamie Hilder on projects exploring the politics and culture of global capitalism. His work has been exhibited in Vancouver at the Or Gallery, Western Front, Contemporary Art Gallery, Charles H. Scott Gallery and Artspeak. He is also a member of the bands Cranfield & Slade, Womankind and Leviathans.

Josée Drouin-Brisebois is the Senior Curator of Contemporary Art at the National Gallery of Canada in Ottawa. She organized exhibitions for the Canadian Pavilion at the Venice Biennale in 2013 (with artist Shary Boyle) and in 2011 (with artist Steven Shearer). She has curated a number of important exhibitions for the National Gallery including *Arnaud Maggs: Identification*; *It Is What It Is: Recent Acquisitions of New Canadian Art*; *Nomads*; and *Caught in the Act: The Viewer as Performer*. Drouin-Brisebois also co-curated *Misled by Nature: Contemporary Art and the Baroque* with Catherine Crowston and Jonathan Shaughnessy at the Art Gallery of Alberta, Edmonton, as well as *Spectral Landscape* and *The Shape of Things* with David Liss at the Museum of Contemporary Canadian Art, Toronto.

Cassandra Getty is Curator of Art at Museum London in Ontario. She holds a master's degree in the History of Art from the University of Victoria, and a Bachelor of Fine Arts from the University of Windsor. She curated the London version of *Myfanwy MacLeod, or There and Back Again*. Other recent projects include *Thelma Rosner: Homeland*; *L.O. Today; Kim Adams: One For the Road* (with Melanie Townsend) and *Imaging Disaster* (with Adam Lauder).

Joseph Monteyne is an art historian who teaches in the Department of Art History, Visual Art and Theory at the University of British Columbia. He previously taught art history at the State University of New York in Stony Brook, New York. His writing on seventeenth century painting and print culture, twentieth century art, contemporary independent magazine culture and American popular imagery has been published in journals that include *Art History* and *Oxford Art Journal*, and in edited volumes published by Bis, Gingko, Thames and Hudson, and Nouveau Monde Editions. His first book, *The Printed Image in Early Modern London: Urban Space, Visual Representation and Social Exchange*, was published by Ashgate in 2007. His second book, *From the Still-Life to the Screen: Print Culture, Display, and the Materiality of the Image in Eighteenth Century London* was published by Yale University Press in 2013.

Kathy Slade is Co-director (with Brady Cranfield) of *The Music Appreciation Society* and the Founding Editor of ECU Press. She runs READ Books at the Charles H. Scott Gallery and, together with Keith Higgins, Publication Studio Vancouver. Her essays have appeared in a number of journals and exhibition catalogues. Slade has exhibited her artworks widely in North America, China, Europe and the UK. She is in the art band Cranfield & Slade, which has produced two concept albums on coloured vinyl titled *12 Sun Songs* and *10 Riot Songs*.

ARTIST'S ACKNOWLEDGEMENTS

I wish to express my great appreciation to Cassandra Getty, Curator of Art at Museum London for her interest in my work and in getting the ball rolling. I would like to convey my deepest gratitude to Grant Arnold, Audain Curator of BC Art for his infinite patience and willingness to give his time so generously. I am also grateful to Black Dog Publishing, specifically Duncan McCorquodale, Albino Tavares and Nick Warner, for their commitment to this monograph and their openness to my input. I extend my sincere thanks to Josée Drouin-Brisebois, Joseph Monteyne and the Music Appreciation Society (Brady Cranfield and Rachel Topham) for the thought and time they put into their essays and to Trevor Mills and Rachel Topham for their extensive work preparing the images for reproduction.

I would also like to thank Catriona Jeffries and the staff at Catriona Jeffries Gallery for their valuable support on this project. My thanks to Michael Batty at Fine Art Framing, Bi-Ying Miao and Matt Compeau at Hot Pop Factory, Josh Riddle at Riddleworks, Matt Parisien at Malaspina Printmakers, and Boelling Smith Design. I also wish to thank the staff at Museum London and the Vancouver Art Gallery for their help in planning, execution and installation of the exhibition.

Finally, special thanks to my sister Jennifer and brother-in-law Chris Specht for their support and encouragement throughout the project. Chris gave me his 1977 Camaro, which was once his pride and joy.

Published in conjunction with *Myfanwy MacLeod, or There and Back Again*, an exhibition organized by Museum London and the Vancouver Art Gallery, curated by Cassandra Getty and Grant Arnold. Presented at Museum London from April 20 to September 23, 2013 and at Vancouver Art Gallery from March 8 to June 8, 2014.

Publication Coordination: Tracy Stefanucci
Design: Albino Tavares at Black Dog Publishing Ltd
Digital image preparation: Trevor Mills and Rachel Topham, Vancouver Art Gallery

Cover: *Ramble On*, 2013
 1977 Camaro Rally Sport, steel stand
 221 x 493 x 176 cm
 Courtesy of Catriona Jeffries Gallery

Exhibition Support

Visionary Partner:
David Aisenstat

Generously supported by:
Douglas E. Bolton
Jane Irwin and Ross Hill

Publication Support

RBC Foundation®

The Vancouver Art Gallery is a not-for-profit organization supported by its members, individual donors, corporate funders, foundations, the City of Vancouver, the Province of British Columbia through the British Columbia Arts Council, and the Canada Council for the Arts.

Vancouver Art Gallery
750 Hornby Street
Vancouver BC V6Z 2H7
Canada

Tel: 604 662 4700
www.vanartgallery.bc.ca

ISBN 978-1-908966-53-7

British Library Cataloguing-in-Publication Data.
A CIP record for this book is available from the British Library.

Black Dog Publishing Limited
10a Acton Street
London WC1X 9NG
United Kingdom

Tel: +44 (0)20 7713 5097
Fax: +44 (0)20 7713 8682
info@blackdogonline.com
www.blackdogonline.com

Black Dog Publishing Limited, London, UK, is an environmentally responsible company. *Myfanwy MacLeod, or There and Back Again*, is printed on a sustainably sourced paper.

Vancouver Artgallery

MUSEUM | LONDON

art design fashion
history photography
theory and things

black dog publishing

www.blackdogonline.com london uk